WONDERS

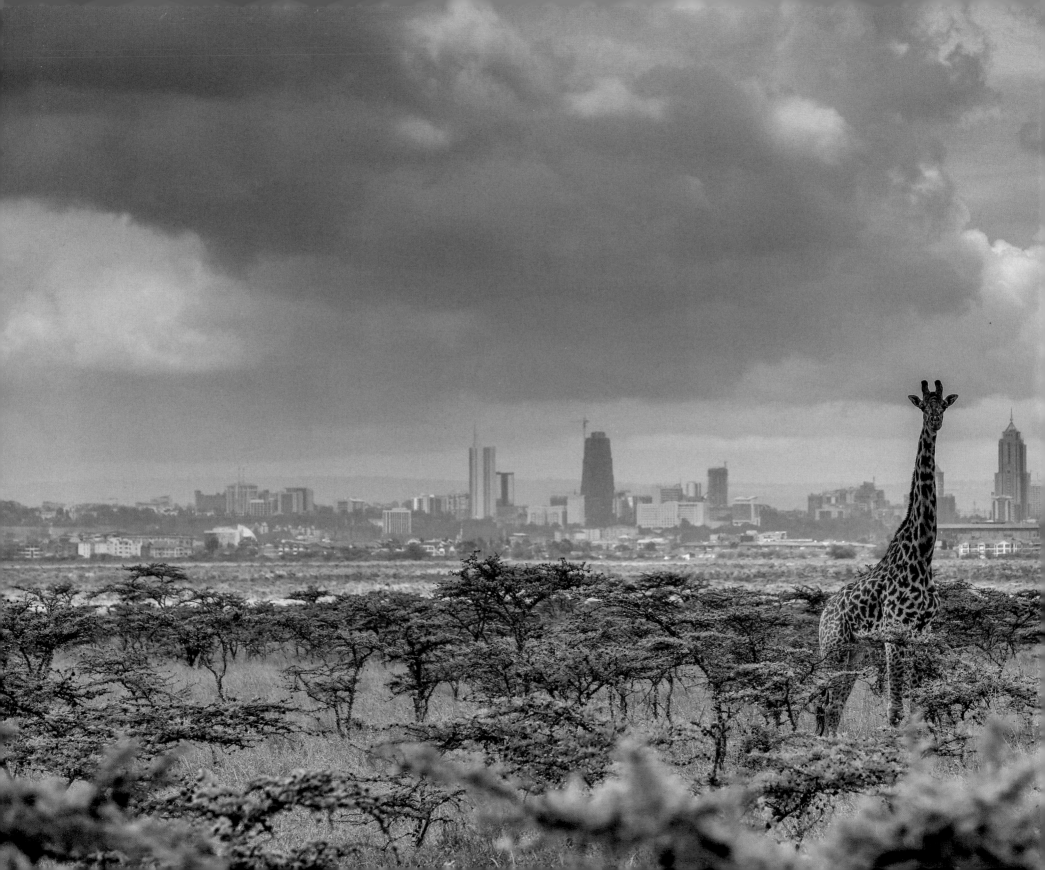

WONDERS

Spectacular Moments in Nature Photography

Curated by Rhonda Rubinstein
and the California Academy of Sciences

Introduction by Dr. Sylvia A. Earle

Essays by Suzi Eszterhas and Dr. Jonathan Foley

CHRONICLE BOOKS
SAN FRANCISCO

FOREWORD BY **Rhonda Rubinstein**

Seeing the Big Picture

Photographs change the way we see the world. They help us understand a slice of life that we'd never considered before. Wildebeests leap off a cliff during the Great Migration. An attacking seal forces a flightless penguin to attempt lift-off. A cougar prowls the night in Hollywood. The photographs in this book remind us that there is a huge, stunning, and still natural world out there, full of striking creatures, bizarre behaviors, and breathtaking landscapes. They show us animals reacting to each other, to the world around them, and to us. They immerse us in the shock and wonder of it all.

Before you sink into the sofa, refreshment in hand, to page through these extraordinary photographs, consider the journey from pixels to page. Nature photographers go, quite literally, to the ends of the Earth, to the places we might never visit, and brave weather and conditions that we avoid, in order to capture a single moment. These adventurous souls wait for hours, if not days, for the bird to return to its nest, the polar bear to emerge, or the skies to clear and reveal the northern lights, without any guarantee of these things actually occurring. To know where and when to wait, the photographers learn as much as possible about the animals and phenomena, using techniques familiar to the scientists who study them. And they are as careful as the scientists not to disrupt what they photograph. Often the photographer's aim is to make us care about a creature we didn't even know existed. With luck, they capture that perfect moment.

Back home, days, weeks, or even months later, the photographer selects one or more images from that particular trek to enter into the BigPicture Natural World Photography Competition. We launched this international competition at the California Academy of Sciences in 2014 in order to showcase the amazing diversity of life on Earth and celebrate the photographers dedicated to its preservation. Every year we receive thousands of submissions from hundreds of photographers. To review these, we invite people whose day jobs involve creating, commissioning, editing, distributing, or writing about photographs: a jury of influential photo editors and accomplished photographers from around the globe.

What makes a winning photograph? Our judges select the defining moment in nature, those rare sightings, unusual occurrences, and surprising encounters. They evaluate the composition of forms and natural patterns, shifts of light and focus, and contrasts of color that enhance the drama, surprise, and singularity of the scene.

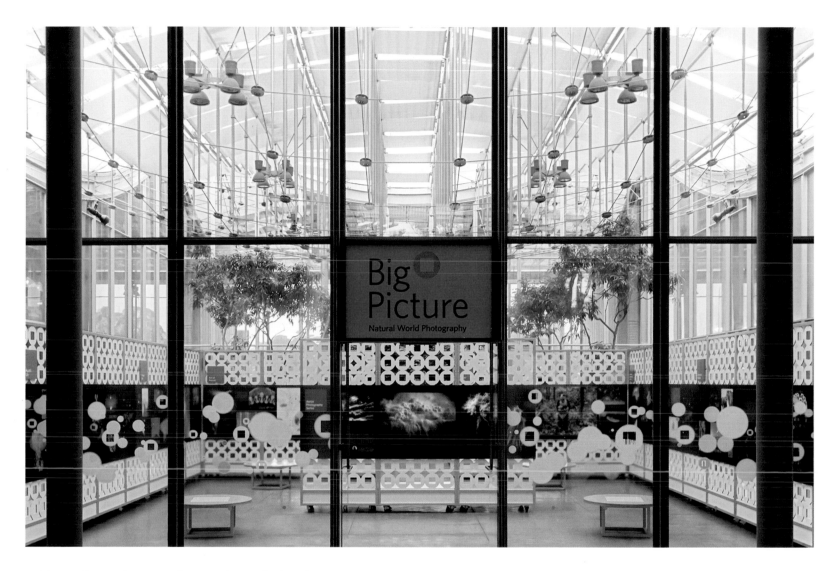

Remarkable photographs bring the outside inside the California Academy of Sciences in San Francisco. Photo by Kat Whitney.

The year's award-winning photographs are displayed each summer in an acclaimed exhibition at the museum. The images are accompanied by the photographers' stories and by Academy scientists' perspectives on the less visible context of each photograph. Then the exhibit is gone, disappearing almost as quickly as the moments captured in the photographs. But with this book, and the generosity of the photographers, we can preserve these fleeting moments, these dioramas of light on a printed page, much like the specimens in our scientific collections.

Nature photography is both art and science. Territorial battles, courting rituals, family dynamics, food gatherings, and the movement of multitudes persist as themes in science and throughout the history of art.

As humans who perch nearby on the evolutionary tree, we relate to the dramas depicted in these photographs. They are the great stories of life on Earth, captured in a millisecond, but in the making for millennia.

Rhonda Rubinstein is the creative director of the California Academy of Sciences and cofounder of the BigPicture Natural World Photography Competition.

Where in the world were these photographs taken?

Every day nature's spectacle unfolds in unexpected moments. Here's where photographers captured their unique perspectives on the wonders of our planet.

JOSHUA TREE NATIONAL PARK, CALIFORNIA

PUGET SOUND, WASHINGTON

TUMUCH LAKE, BRITISH COLUMBIA, CANADA

YELLOWSTONE NATIONAL PARK, WYOMING

GREEN VALLEY, ARIZONA

BOSQUE DEL APACHE NATIONAL WILDLIFE REFUGE, NEW MEXICO

CHURCHILL, CANADA

JÖKULSÁRLÓN,

SOUTHWEST ALENTEJO AND V

MANITOBA, CANADA

LOS ANGELES, CALIFORNIA

SAN DIEGO, CALIFORNIA

OAHU, HAWAII

MEMPHIS ZOO, TENNESSEE

BAJA CALIFORNIA, MEXICO

CALI, COLOMBIA

AUSTIN, TEXAS

CABO PULMO, MEXICO

OKEFENOKEE NATIONAL WILDLIFE REFUGE, GEORGIA

LAKE WORTH LAGOON, RIVIERA BEACH, FLORIDA

HOMESTEAD, FLORIDA

YASUNI NATIONAL PARK, ECUADOR

CHOCÓ RAINFOREST, ECUADOR

FRESIA, LOS LAGOS REGION, CHILE

TORRES DEL PAINE NATIONAL PARK, CHILE

PLÉNEAU ISLAND, ANTARCTICA

CUVERVILLE ISLAND,

Legend:
- In the Water
- In the Air
- On Land
- Wild Places
- Art of Nature
- Human/Nature

NW ICELAND

ANDALUSIA, SPAIN

HUELVA, SPAIN

EAST YORKSHIRE, ENGLAND

TELEMARK, NORWAY

SAHARA DESERT, MOROCCO

WEHNINGEN, GERMANY

VALSAVARENCHE, ITALY

TYRRHENIAN SEA, ITALY

GEMENC FOREST, HUNGARY

LAKE KERKINI, GREECE

RED SEA, MARSA ALAM, EGYPT

DUBAI, UNITED ARAB EMIRATES

MAASAI MARA, KENYA

MAASAI MARA, KENYA

MAASAI MARA, KENYA

MUMBAI, INDIA

MAHARASHTRA, INDIA

WOLONG, CHINA

NAGANO, JAPAN

TAOYUAN, TAIWAN

SAMUT SONGKHRAM PROVINCE, THAILAND

UDAWALAWE NATIONAL PARK, SRI LANKA

TABIN WILDLIFE RESERVE, MALAYSIAN BORNEO

LEMBEH STRAIT, INDONESIA

BUNAKEN NATIONAL MARINE PARK, INDONESIA

WAST NATURAL PARK, PORTUGAL

GAINESVILLE, FLORIDA

NAIROBI, KENYA

NDUTU, TANZANIA

WOLLONGONG, AUSTRALIA

BONAIRE, CARIBBEAN NETHERLANDS

CHAPADA DOS VEADEIROS, BRAZIL

EMAS NATIONAL PARK, BRAZIL

CHOBE NATIONAL PARK, BOTSWANA

MALILANGWE WILDLIFE RESERVE, ZIMBABWE

CANARY ISLANDS, SPAIN

CIUDAD DE PIEDRA, BOLIVIA

ETOSHA NATIONAL PARK, NAMIBIA

EASTERN CAPE PROVINCE, SOUTH AFRICA

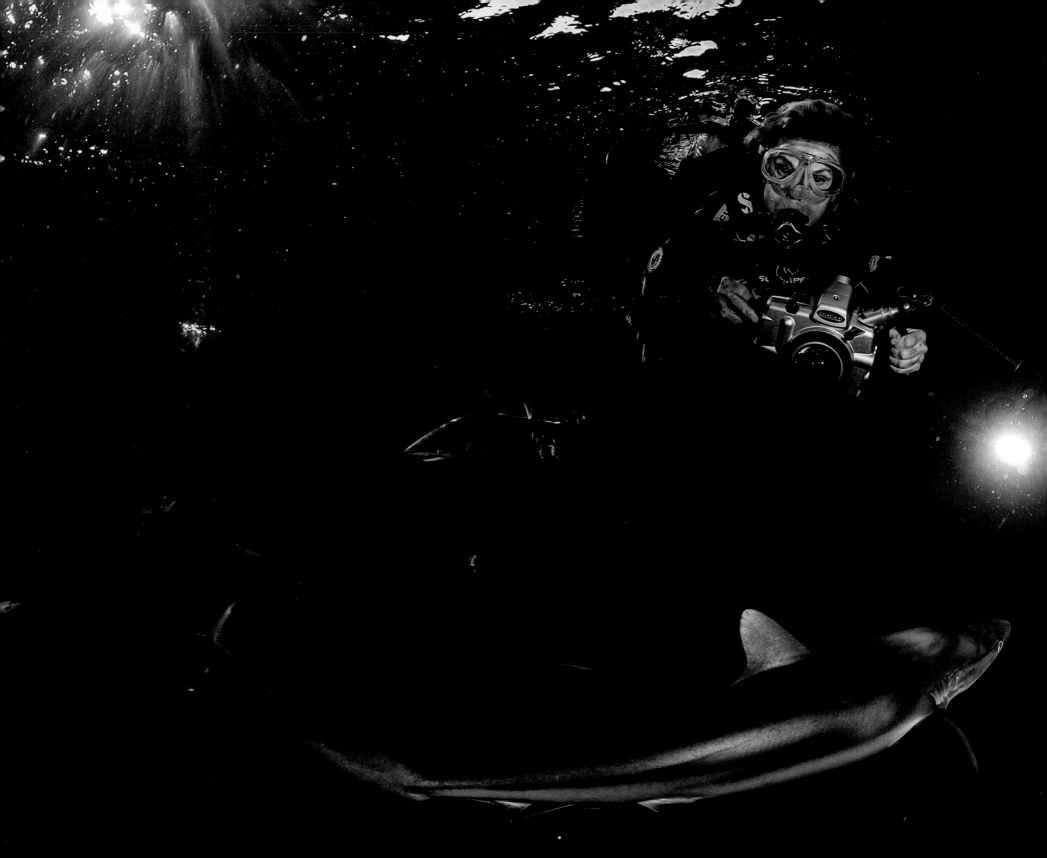

Beyond Words

"What is Art, monsieur, but Nature concentrated?" —Honoré de Balzac

Late in the 19th century, William Henry Jackson's epic photographs of sweeping landscapes, pristine forests, and wondrous wild animals helped inspire members of the U.S. Congress and President Ulysses S. Grant to establish the nation's first national park—Yellowstone. People who had never seen a canyon or coyote, let alone a bear or buffalo, began to experience those things vicariously through photographic images, and were inspired to support protection for a growing network of parks and reserves, as well as policies aimed at safeguarding natural, historic, and cultural treasures that might otherwise be forever lost.

Knowing does not guarantee caring, but you cannot care about something if you do not know it exists.

When Jackson began taking and field-processing photographs in the 1800s, his 300 pounds of equipment—cameras, stands, trays, chemicals, glass plates, bags, brushes, and more—filled a wagon. As technology improved, a hearty pack mule was sufficient to support his operations; and in later years, he carried his own gear, a nifty, lightweight 35mm Leica.

Dr. Sylvia A. Earle photographs a silky shark in Cuba in February 2017, photographed by Michael Aw.

My first experience with a camera was with a Kodak Brownie Reflex. It recorded 12 black-and-white, more-or-less in-focus images per roll. Years later, in 1964, I packed a well-worn 35mm Pentax as a vital piece of equipment, chosen to document encounters with people and wildlife during an oceanographic expedition to the Indian Ocean. Keenly aware of the damage salt spray could do to my beloved camera, I watched in horror when one of my shipmates, Frank Talbot (subsequently executive director of the California Academy of Sciences), leaped overboard with an elegant new camera hanging around his neck. I had not yet heard about the breakthrough in design—O-ring seals—that protected the inner workings of Frank's Calypso camera, conceived by ocean explorer Jacques Cousteau and later marketed by Nikon in a popular series of pocket-size Nikonos underwater cameras.

As a scientist, I take photographs to document what I see. This visual log complements field notes and records vital evidence that transcends words. Using a Nikonos II with a 15mm lens and many rolls of 36-exposure Kodachrome film, I snapped thousands of underwater pictures to identify individual humpback whales during a research project led by cetacean expert Roger Payne. Unintentionally, I secured a record of the whale named Daisy at the moment when late afternoon sunlight magically framed her enormous body with golden shafts streaming through a deep indigo ocean. The image scored a rare multipage foldout in *National Geographic* magazine, evidence that occasionally, if you try often enough (or sometimes, when you're not even trying), a photograph can be more than just a photograph.

In 1969, a year after the *Earthrise* image revealed a distant Earth with the moon in the foreground, images of Earth made by astronauts on the moon transfixed and transformed viewers globally. They may be the most important photographs ever taken. It was one thing to imagine our home planet as a tiny blue speck in a universe of beautiful but entirely inhospitable planets, moons, and stars, and quite another to see that reality captured on film. Soon, a flood of images of Earth from spacecraft and aircraft yielded evidence of global change: glaciers shrinking, shorelines shifting, polar ice melting, cities and industrial farms expanding, and forests disappearing.

Fast-forward to today, when those seeking to document the nature of life on Earth—from the skies above to the great depths of the sea—have access to a dizzying range of photographic equipment. Technologies developed in recent decades give photographers "superpowers" that make it possible to film the flow of city traffic and the pathways of ships from space; capture the split-second wingbeats of bats, birds, and bees; make visible the smallest living things; and even take photographs in what appears to be total darkness. Minute cameras can be propelled up into the sky by a drone, tucked inconspicuously into a tie clip, or worn as a watch. Cameras that double as cell phones capture sharp, full-color images that can be shared instantaneously with thousands of people globally. But photographic equipment designed for special purposes can still fill a wagon or require the services of a spacecraft or submarine that far outweighs Jackson's pack mule.

In the summer of 2016, my daughter Elizabeth Taylor, CEO of Deep Ocean Exploration and Research, Inc., wanted to record images of deepwater bioluminescent bamboo coral. She arranged with the Canon corporation to "house" one of their new 4-million ISO cameras in a University of Hawaii three-person 2,000-meter Pisces submarine. Her teenage sons were trained to operate the camera during dives to the fields of six-foot-high coral spirals that I had first encountered in 1979 while walking on the seafloor in the one-person diving suit, JIM. When the corals are touched, rings of brilliant blue light pulse up and

Images such as these are precisely what is needed to inspire new generations of people to know and care about wild places and wildlife, and to take action while there is still time.

down the slender stalks, a dazzling show that I could witness but not document because no existing camera could record more than blurry black-and-white blobs of light. Advanced digital technology in the hands of my grandsons could capture it, and the resulting images have now been seen by millions in the National Geographic film *Sea of Hope*.

The powerful photographs included in this volume, taken by winners of the California Academy of Sciences' BigPicture Natural World Photography initiative, could not have been produced using the cameras available to Jackson during his wilderness journeys. But great photographs can be made with modest equipment, and the finest cameras will yield modest results unless they are masterfully operated or, as with my photo of Daisy the whale, dumb luck happens.

State-of-the-art systems coupled with technical and artistic skills helped make possible the photographs in this extraordinary collection, but the results do more than capture moments in time that document history and please the eye. They tell stories, arouse sympathy, provoke joy, and make you gasp with wonder.

Images such as these are precisely what is needed to inspire new generations of people to know and care about wild places and wildlife, and to take action while there is still time to save rhinoceroses, reverse the decline of coral reefs, respect the sanctity of old growth forests, and realize what should be obvious: We must care for all of the natural world as if our lives depend on it—because, of course, they do.

Dr. Sylvia A. Earle is a National Geographic Explorer in Residence, Ocean Elder, founder of Mission Blue, and founder of Deep Ocean Exploration and Research Inc. She is also a fellow and former research associate and curator of Phycology at the California Academy of Sciences.

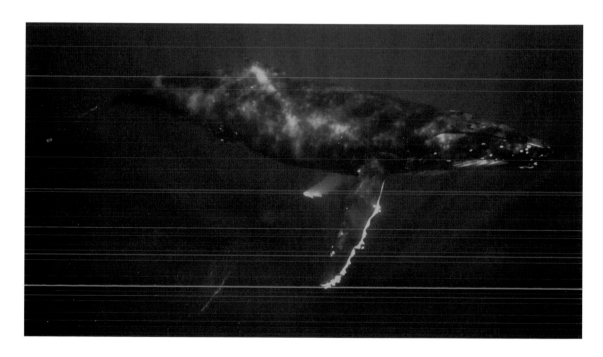

The whale known as Daisy, captured by Dr. Sylvia A. Earle's camera and widely seen in the January 1979 issue of National Geographic *magazine.*

In the
Water

From shore we
focus on the surface
of the water, but to plunge below is to enter a world where a multitude of
creatures thrive in complex communities. An exquisite portrait
of a sea lion, fish, or crab is just as likely to include an unex-
pected organism—or a hundred of them. Look closer: Inside the
mouth of a fish is not food, but its brood. The shrimp's brilliant
red environs turn out to be the gills of a sea slug, and the scene
radically shifts scale. The variety of animals, plants, and other
organisms that spend most of their time in oceans, rivers, and
lakes is staggering.

For all we do know, we can still only imagine how the multi-
colored peacock mantis shrimp, with her bounty of red eggs,
appears to her partner—their alien-looking eyes have four times
as many color photoreceptors as humans'. Nestled inside
astonishingly colored corals or set against an eerie backdrop of
tentacles, many images of life underwater have an otherworldly
look. The startling photographs in this chapter may take your
breath away, but luckily no scuba gear is needed here.

The daring and ingenuity of these photographers is also
awe-inspiring. It is challenging enough to make great por-
traits of fast-moving creatures that range in scale from tiny
to tremendous. But in capturing these life-and-death moments,
photographers of the aquatic world, often laden with heavy
equipment, must also keep an eye on maintaining their own
position in the food chain.

Otherworldly. What a fresh way to look at a marine mammal! Beautifully composed, lovely light, the tension just before the bear breaks the surface— this is a fantastic moment.

—KATHY MORAN, SENIOR EDITOR FOR NATURAL HISTORY AT *NATIONAL GEOGRAPHIC* MAGAZINE AND BIGPICTURE COMPETITION JUDGE

The Ice Bear
Paul Souders

Polar bear (*Ursus maritimus*)
Hudson Bay, Manitoba, Canada

This female polar bear peers from beneath a hole in the melting sea ice in Canada's Hudson Bay. "I was sitting in a tiny boat ...," Souders recounts. "The winter's sea ice was melting almost before my eyes as a heat wave had arrived all across northern Canada. As the bear looked up at me through the ice, the image encapsulated the intelligence, mystery, and beauty of the polar bear, amid the many threats they face in a changing world."

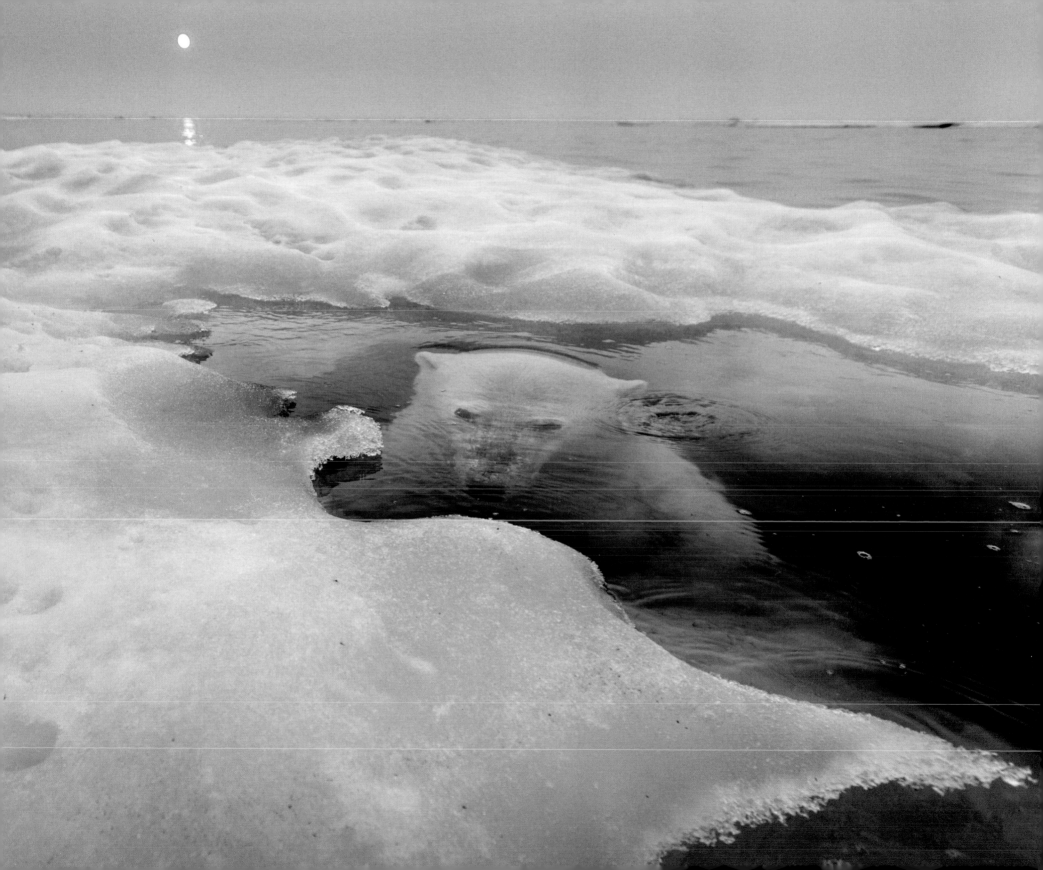

Equal parts sci-fi and haute couture, this mantis shrimp's eggs cascade around her like a ball gown. The photographer beautifully highlights the intense colors and texture by isolating his subject against a dark background.

—KATHY MORAN, SENIOR EDITOR FOR NATURAL HISTORY AT *NATIONAL GEOGRAPHIC* MAGAZINE AND BIGPICTURE COMPETITION JUDGE

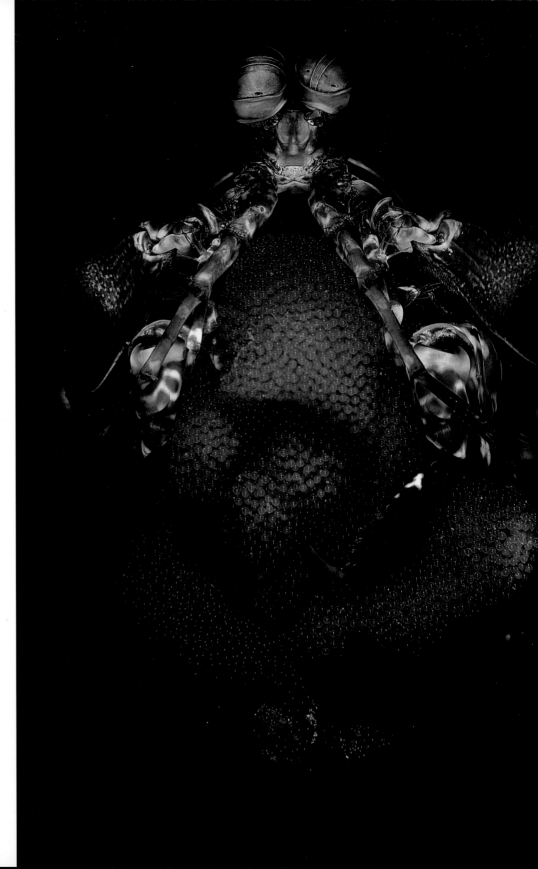

Mantis Mom
Filippo Borghi

Peacock mantis shrimp (*Odontodactylus scyllarus*)
Lembeh Strait, Indonesia

Lembeh Strait's seafloor of black volcanic sands may look desolate, but it teems with many small, weird creatures. It's a popular hotspot for "muck diving" aficionados like Borghi. He was searching the mud for sea slugs when he spotted the tail of a large, brightly colored mantis shrimp behind some rocks. To his surprise, on closer examination, he saw that it was a mother brooding a huge mass of eggs.

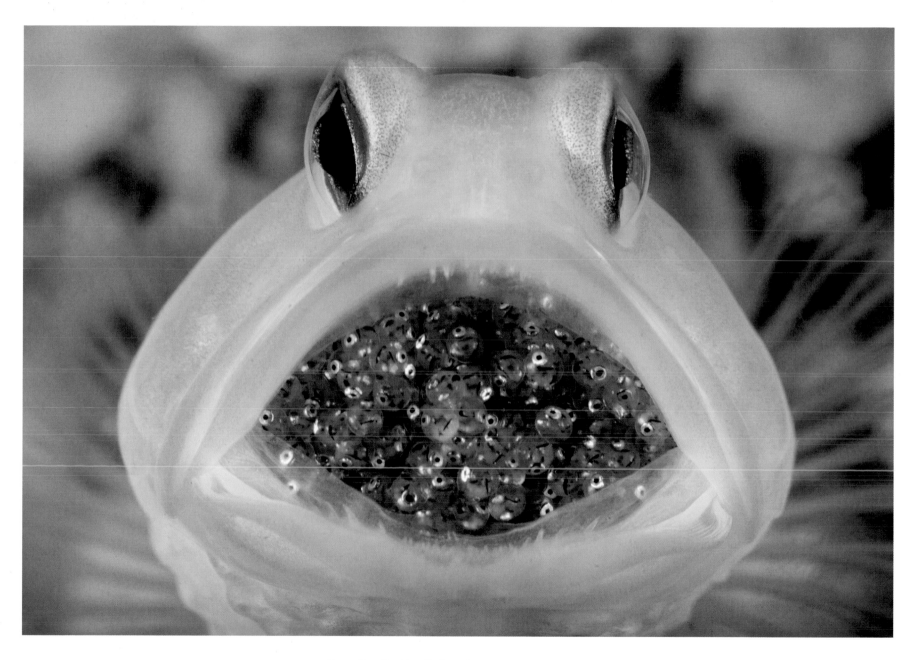

Guarding the Family Jewels
Steven Kovacs

Yellowhead jawfish (*Opistognathus aurifrons*)
Lake Worth Lagoon, Riviera Beach, Florida, USA

Among mated pairs of yellowhead jawfish, the male is the one that carries the eggs, holding them in his mouth until they hatch. This dutiful dad surprisingly made his home in a busy scuba diving spot under Blue Heron Bridge.

An Unexpected Gift
Alejandro Prieto

California sea lion (*Zalophus californianus*)
San Rafaelito, Baja California, Mexico

A sea lion pup playfully swam around Prieto, then
disappeared. It returned with something in its
mouth. "Pups are very friendly," he says, "but this
one especially surprised me with its gift."

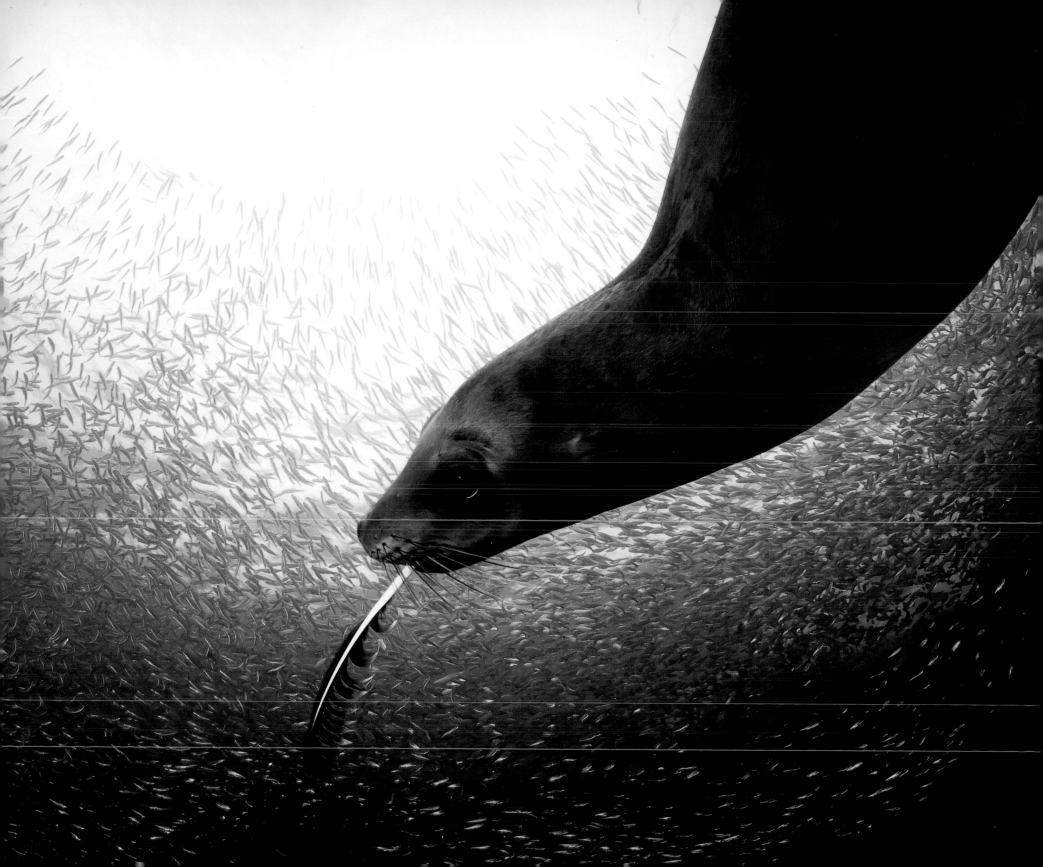

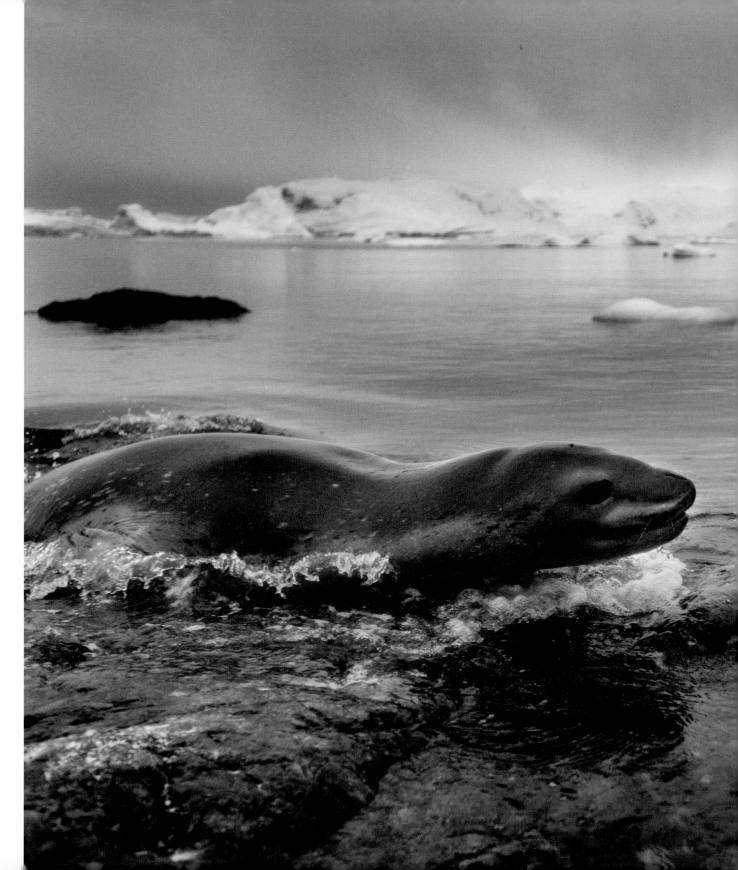

The Luckiest Penguin
Paul Souders

Gentoo penguin (*Pygoscelis papua*)
Leopard seal (*Hydrurga leptonyx*)
Cuverville Island, Antarctica

A leopard seal narrowly misses a leaping gentoo penguin along the rocky shore of the Antarctic Peninsula. Leopard seals are brutally efficient killers in these icy waters, often ambushing penguins as they enter or leave the water. "I love photographing in the Antarctic," says Souders. "The wildlife there are quite comfortable with [human] presence. It's a wonderful opportunity to see the world in a near pristine state."

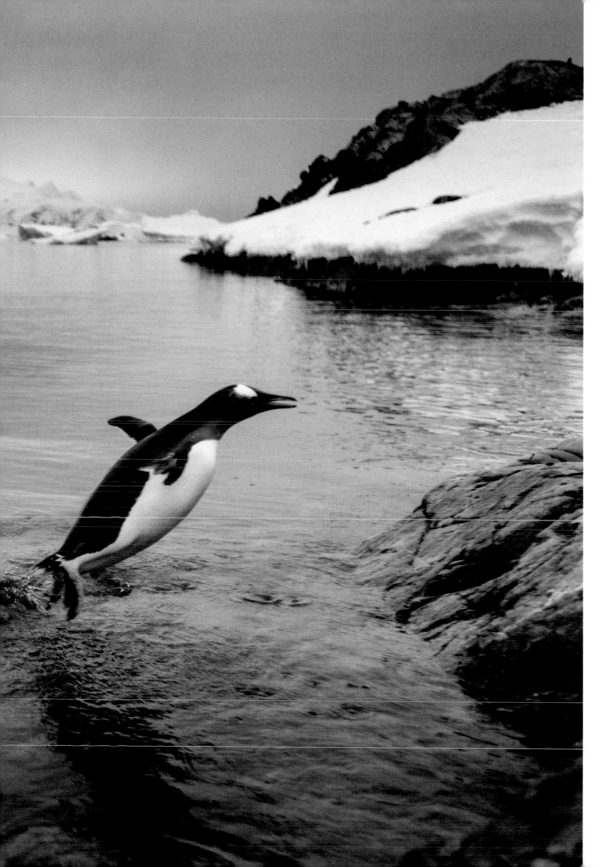

This stunning picture captures Darwin's brilliant insight into how life evolves and survives—which is what the California Academy of Sciences is all about. To survive, the leopard seal needs to eat, but the penguin needs to escape. It's an unceasing competition. The fastest and best-adapted creatures prevail and are able to pass on their genes, and so life evolves and adapts. Life never stands still.

—DR. GREGORY C. FARRINGTON, FORMER EXECUTIVE DIRECTOR OF THE CALIFORNIA ACADEMY OF SCIENCES

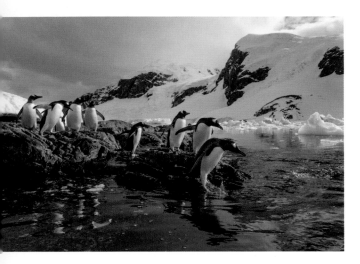

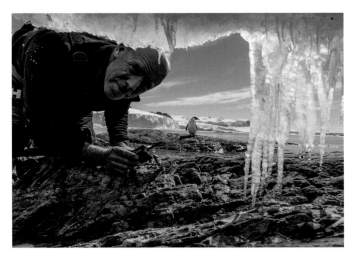

Lucky Enough to Catch the Luckiest Penguin

This photo was taken during my sixth trip to Antarctica. After each Antarctic trip, I always swear I'll never go again. But a year or two later, I find myself walking up the dock toward another sailboat. For this trip, four other photographers and I chartered a 53-foot-long sailboat with a Dutch skipper and his Argentine first mate at the southern tip of Argentina. We spent four weeks on board, including five days sitting on the snow-covered shores of Cuverville Island.

The penguins went about their penguin business and I shot it all, spending 18 hours a day out in the elements. Rather than try to photograph the penguins in the muddy, smelly, and poo-fouled rookeries, I spent most of my time along the shore. The penguins came back and forth each day, heading out to sea to wash up and feed, returning to their nests to share food with their mates and to help protect and warm their eggs. They would hop out of the water onto the rocks and snow, do a bit of preening, and then waddle up the hillside to their nests.

I really wanted to shoot something new on this trip, and one thing I focused on was capturing penguins in flight. Penguins are, of course, flightless birds, but I wanted to capture those brief

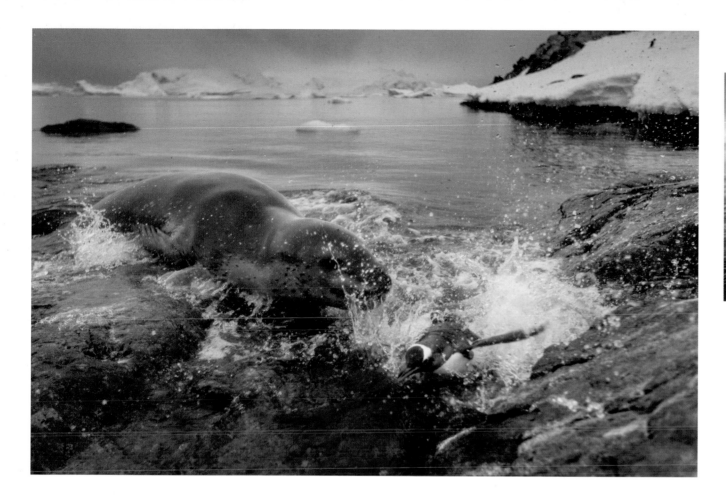

moments when they were in fact, airborne. On our last night in Antarctica, I was standing on shore fiddling with my camera gear, when off in the distance I heard a hiss. I turned to see an enormous leopard seal slithering out of the water and chasing some penguins on the rocks. He missed, and I just stood there, staring dumbly for a moment before scrambling over with a camera. I got nothing.

I alerted the others, and British photographer Ben Cranke joined me on shore to watch for the seal. We sat side by side and watched as the leopard seal repeatedly tried to ambush the penguins on the rocks in front of us. It was one of those unbelievable moments in the wild, sitting less than a yard away from a lethal hunter. I'd never seen anything like this. And there wasn't any way to predict or compose my shots. After several tries I managed to capture an image of the seal's leaping attempt to attack a penguin on shore. The penguin jumped away in a wide-eyed panic at the last possible moment. And the image was over in less than 1/500th of a second.

—PAUL SOUDERS

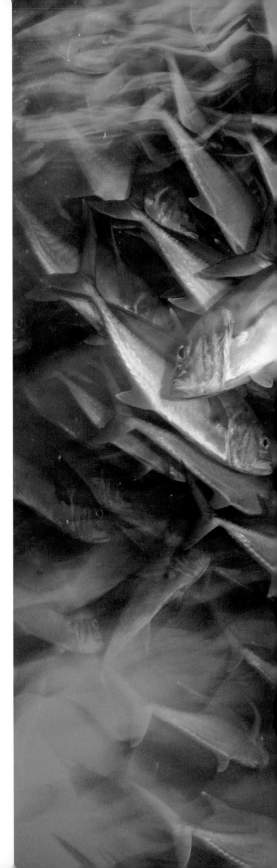

Eye of the (Trevally) Tornado
Octavio Aburto

Yellowfin surgeonfish (*Acanthurus xanthopterus*)
Bigeye trevally (*Caranx sexfasciatus*)
Cabo Pulmo National Marine Park, Mexico

At sunset, a surgeonfish follows a school of trevally to feed upon their calorie-rich droppings. Aburto used a strobe flash, slow shutter speed, and big aperture to freeze the colorful companion amid the swirl of trevally.

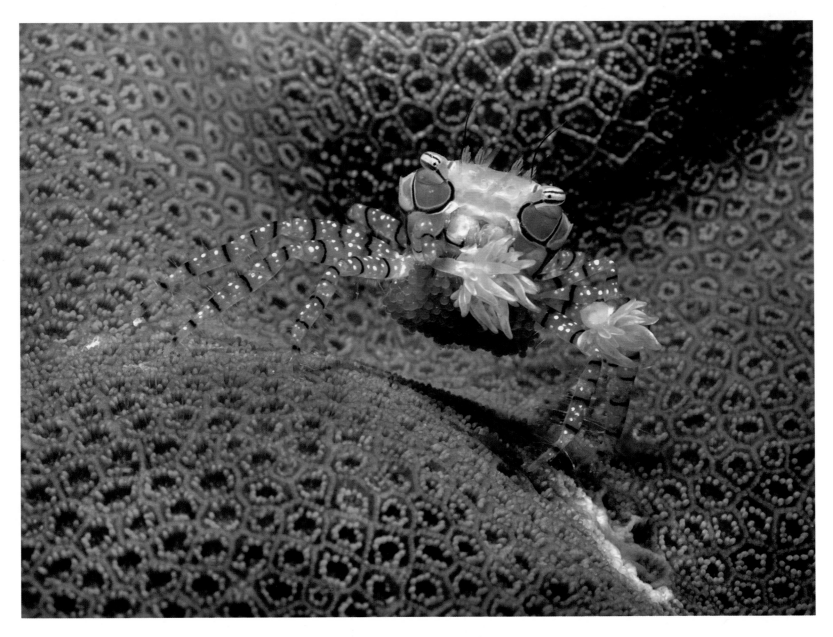

The Boxer and Its Eggs
Alex Varani

Boxer crab (*Lybia tessellata*)
Bunaken National Marine Park, Indonesia

The boxer crab protects its eggs from a perch on a beautiful, green brain coral. The crab earned its name from its tendency to clutch sea anemones within its claws—threatening any encroaching predators with a painful sting.

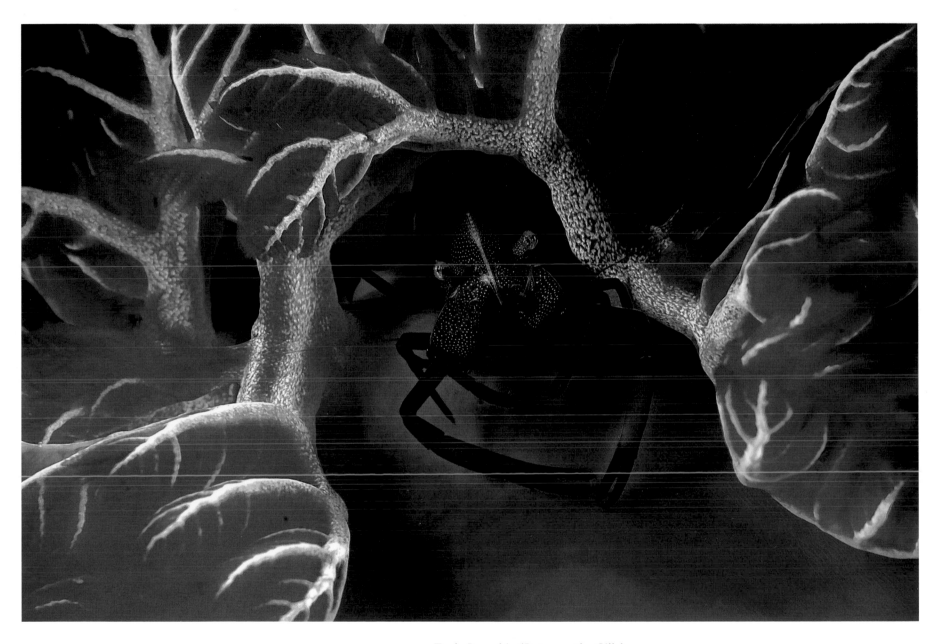

Tra le Branchie (Between the Gills)
Filippo Borghi

Emperor shrimp (*Periclimenes imperator*)
Red Sea, Marsa Alam, Egypt

Under the darkness of night, a Spanish dancer nudibranch—or sea slug—inches across the reef in search of a meal. Nestled between its gills, a tiny emperor shrimp has found refuge on this slow-moving mobile home.

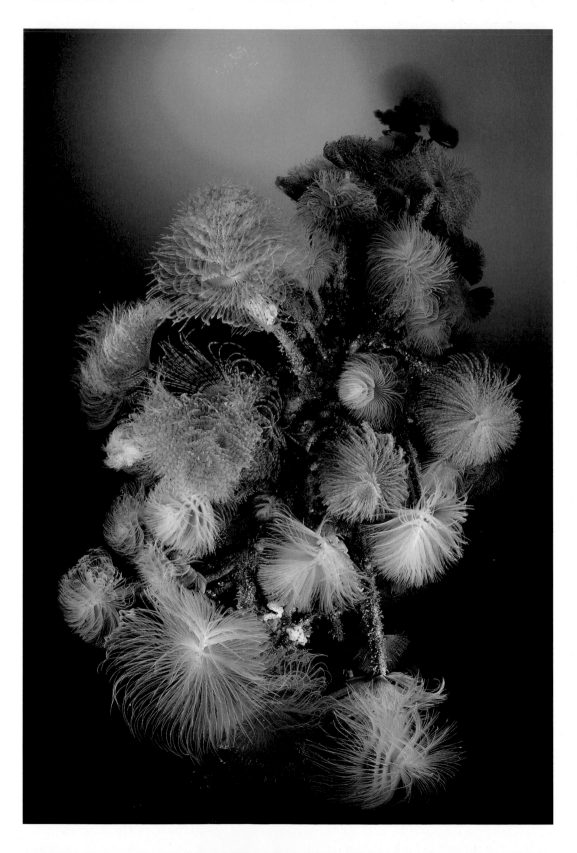

These strikingly beautiful worms play an ecologically important role as filter feeders: They eat phytoplankton, or microscopic algae, removing it from the water with their abundant tentacle plumes. Without healthy populations of filter feeders in the ocean, we would experience more red tides—harmful algal blooms that trigger massive die-offs of marine life.

—TERRENCE GOSLINER, SENIOR CURATOR OF INVERTEBRATE ZOOLOGY AT THE CALIFORNIA ACADEMY OF SCIENCES

Fireworks
Adriano Morettin

Mediterranean fanworms (*Sabella spallanzanii*)
Tyrrhenian Sea, Gulf of Naples, Italy

While diving in the Gulf of Naples, Morettin encountered these tube worms attached to long chains that anchor mooring buoys to the sea bottom. In favorable conditions, their crowns of tentacles open simultaneously— like a burst of fireworks.

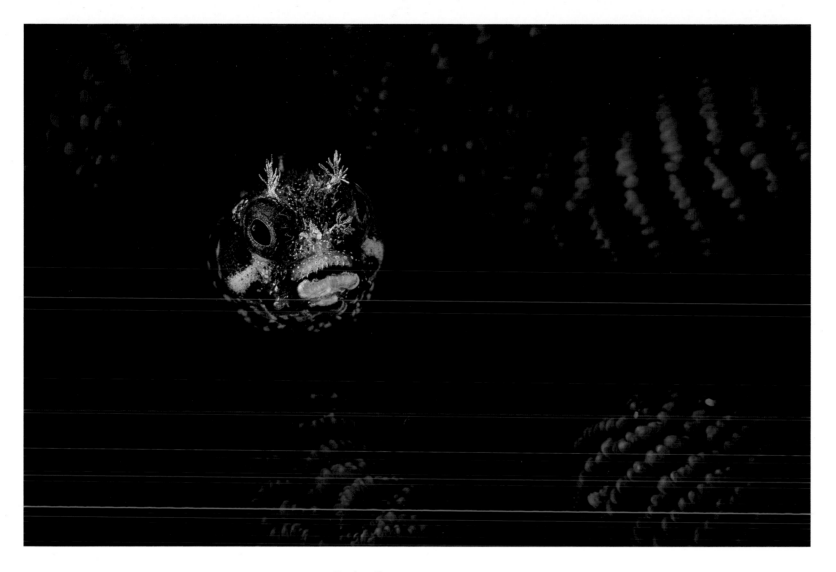

Peek-a-Boo
Beth Watson

Spinyhead blenny (*Acanthemblemaria spinosa*)
Stony coral (*Colpophyllia* sp.)
Bonaire, Caribbean Netherlands

During a dive amid the reefs off the Caribbean island of Bonaire, Watson spotted this pristine and gorgeously patterned stony coral. It was a perfect photographic backdrop for a subject, if she could find one. Soon enough, a spinyhead blenny obliged. "It didn't take long to find this little guy," says Watson. "He was in a convenient location, burrowed in on top of the coral."

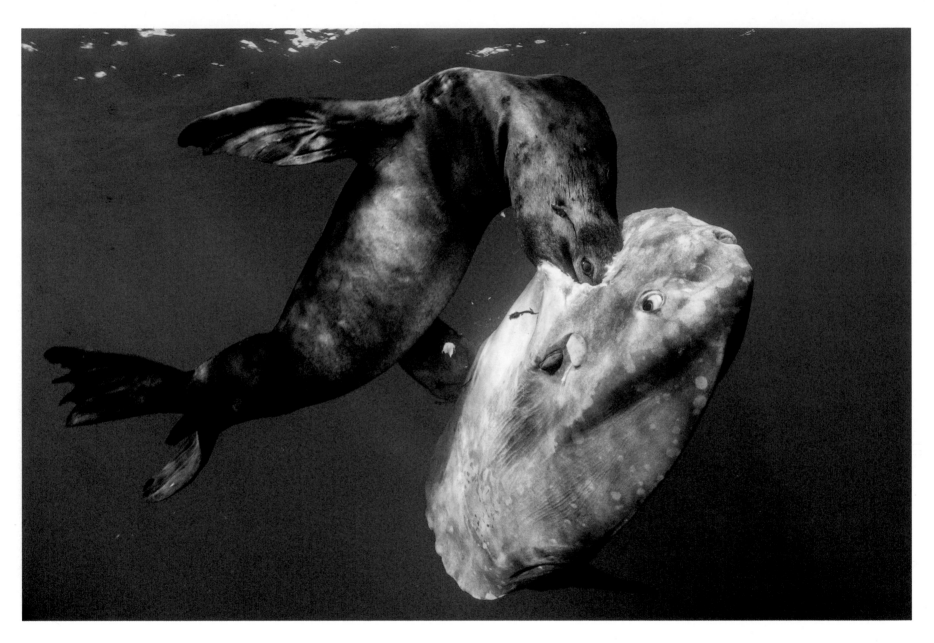

Epic Battle
Ralph Pace

California sea lion (*Zalophus californianus*)
Ocean sunfish (*Mola mola*)
San Diego, California, USA

On a diving trip, Pace witnessed a hungry sea lion feeding upon a sunfish, which put up a prolonged fight. Then, for a second, the scene was calm. As Pace puts it, "The mola looks at his predator as if he is pleading for his life."

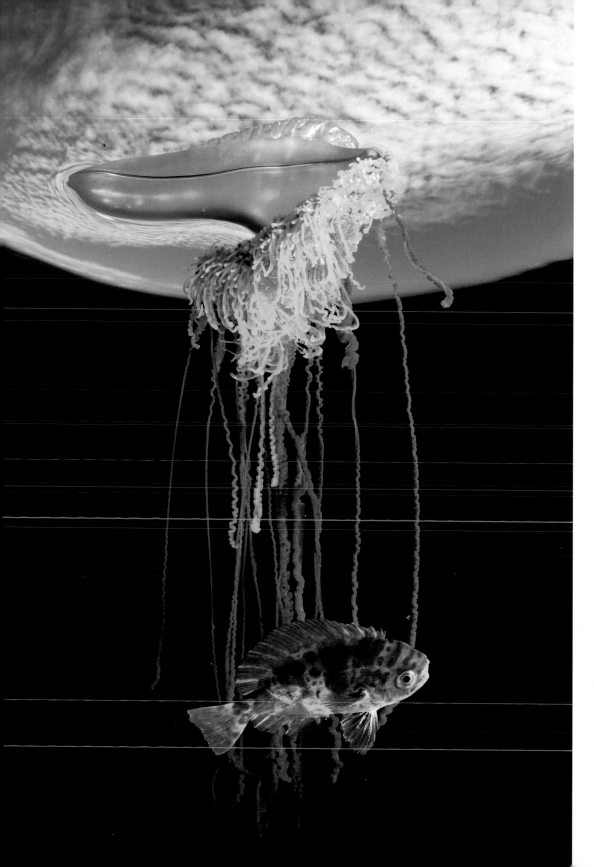

To perfectly photograph a Portuguese man o' war is challenging, and documenting one with a fish lurking by its tentacles is especially rare. Even more remarkable is the composition including sky and clouds, giving the illusion that these creatures are floating in outer space.

—BRIAN SKERRY, PHOTOJOURNALIST, NATIONAL GEOGRAPHIC PHOTOGRAPHY FELLOW, AND BIGPICTURE COMPETITION JUDGE

Deep Space
Eduardo Acevedo

Portuguese man o' war (*Physalia physalis*)
Juvenile imperial blackfish (*Schedophilus ovalis*)
Los Gigantes, Tenerife, Canary Islands, Spain

March and April are the best months in the Canary Islands to see the strange and beautiful Portuguese man o' war, a jellyfish-like colony of organisms. The creature's stinging tentacles can paralyze small prey—but not this particular blackfish species, which is immune and sticks around for protection from predators. Acevedo spent years watching for the perfect convergence of clouds, sunlight, and calm seas to photograph this otherworldly tableau.

Fascinated by flight, we admire birds

for their seemingly effortless ability to soar and glide in the skies. Some travel in dramatic formations or fly tens of thousands of miles annually—all without a carbon footprint. But their grace, beauty, and skill are just as intriguing on land and in the water.

The beauty of birds may be a double-edged feather. Prized for their plumage, great egrets were almost hunted to extinction. A photograph of a large gathering tells a dramatic tale of recovery, but the image's rich blue hues have a slightly eerie cast that reminds us of the bird's darker past.

What makes for great portraits of these small, swift creatures? Great photographers get eye to eye with an eagle, spot a camouflaged owl, and show us why "hawk" is synonymous with aggressive strategy. They also capture the great tenderness of birds who mate for life—the male gannet who offers the female a gift of a garland, or the pair of white storks nestled into a remote mountain peak that could be touted as a romantic getaway.

It's always a challenge to get one's ducks in a row—or pelicans in position—but with patience, a photographer can quite possibly produce a perfect picture.

In the Air

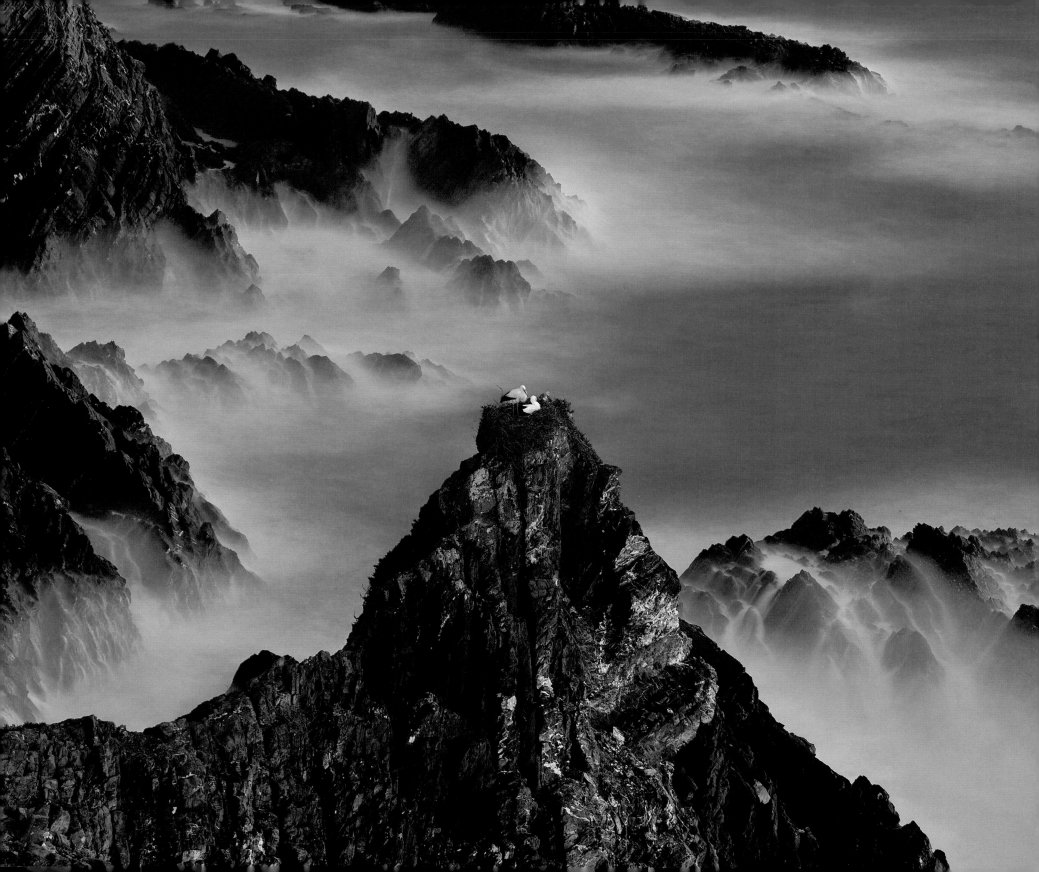

Pinnacle Perch
Francisco Mingorance

White stork (*Ciconia ciconia*)
Southwest Alentejo and Vicentine Coast Natural Park, Portugal

A high tide, a cloudless night, a crescent moon—
and a red flash. All these converged to produce
Mingorance's harmonious image of white storks
nesting atop a wind-buffeted peak on the wild
Atlantic coast of southern Portugal.

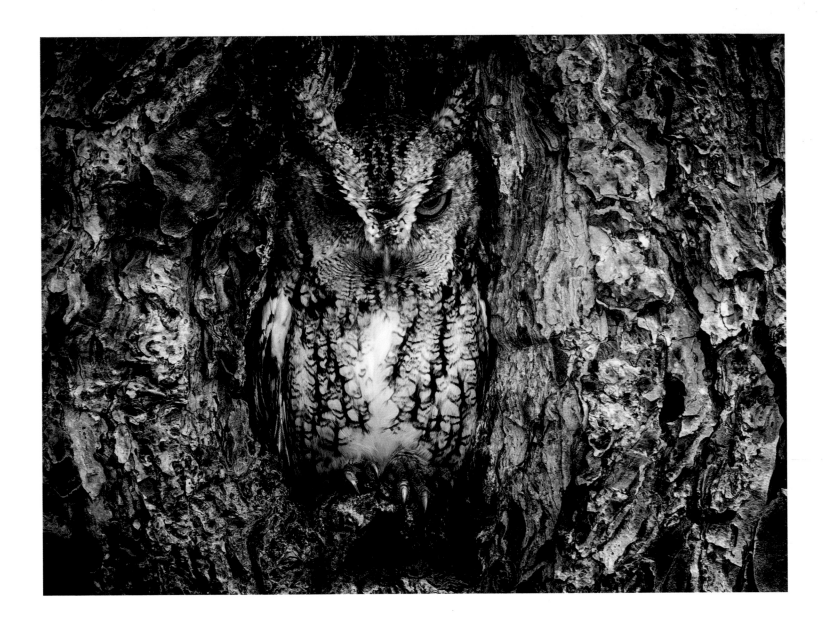

Master of Disguise
Graham McGeorge

Eastern screech owl (*Megascops asio*)
Okefenokee National Wildlife Refuge,
Georgia, USA

Superbly camouflaged, eastern screech owls are more
often heard than seen. At daybreak, McGeorge spotted
this nocturnal raptor hunkering down in a pine tree,
where it had taken over a woodpecker's nest.

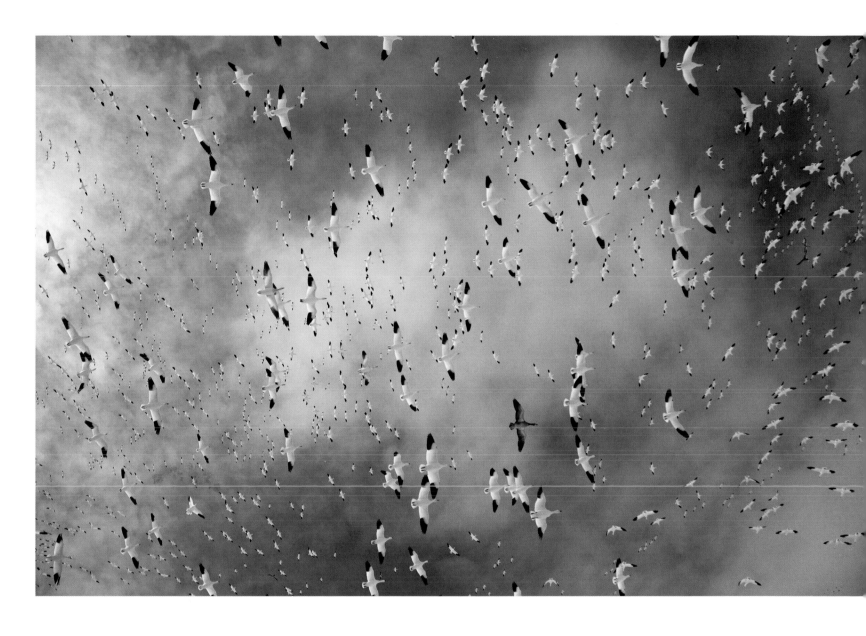

Snow Globe
Denise Ippolito

Snow geese (*Chen caerulescens*)
Bosque del Apache National Wildlife Refuge,
New Mexico, USA

A swirling storm of snow geese fills the sky. Tens of thousands of migratory waterfowl overwinter each year in marshes and farmlands along the Rio Grande. On a rare snowy day, Ippolito spent 12 straight hours photographing honking flocks of geese—including the occasional "blue" snow goose with dark plumage—as they formed fantastic patterns in the air.

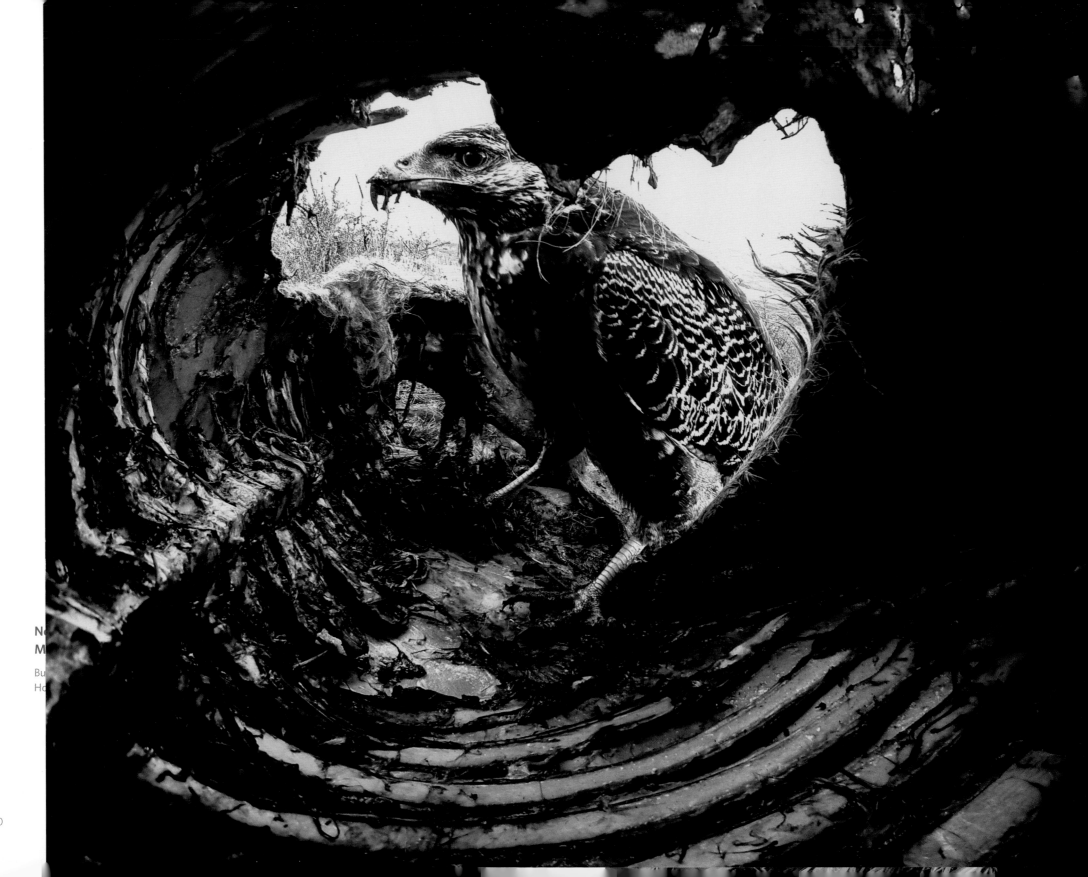

Circle of Life
Kevin Zaouali

Black-chested buzzard-eagle (*Geranoaetus melanoleucus*)
Guanaco (*Lama guanicoe*)
Torres del Paine National Park, Chile

While hiking, Zaouali found a guanaco—a llama relative—
that had been killed by cougars. He set a GoPro camera
inside the carcass and left, returning hours later. This vivid
image of a magnificent buzzard-eagle awaited.

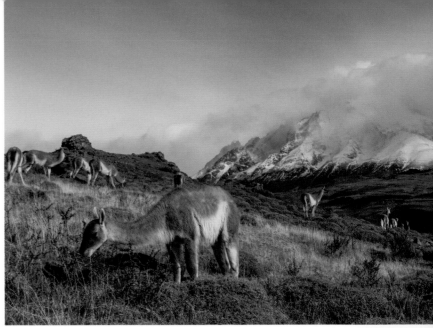

Finding the Unexpected Story

One awesome moment—that is what I live for. Each time I begin a new mission to photograph wildlife, the first thing I determine is how to tell the story in a new way. The point of view is essential: Should I go underwater, walk on land, or use a drone to take pictures from the sky?

These images were taken on my second trip to Chile to photograph cougars in the Andes. Searching for cougars always means finding many guanacos, since cougars hunt the llama-like creatures. After a cougar has eaten its fill of a fresh guanaco kill, it will cover the carcass with grass and sticks to hide it from scavengers. The cougar will return later to continue feeding.

On my third day hiking in Patagonia's Torres del Paine National Park, I saw an opportunity to get an unusual photo of a cougar. A guanaco carcass lay on the mountainside. I wanted to tell the story of the cougar eating the guanaco, but taken from a new point of view: from inside the body. I prepared my GoPro

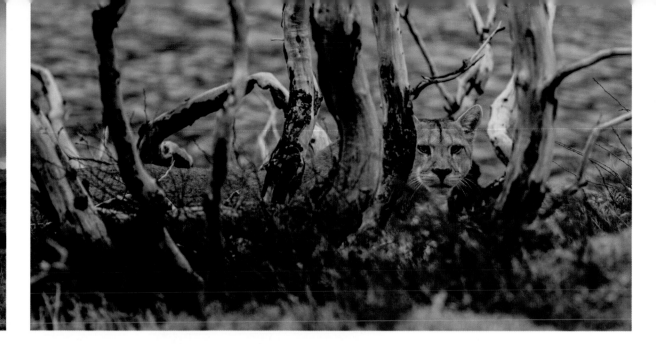

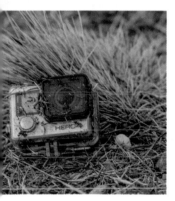

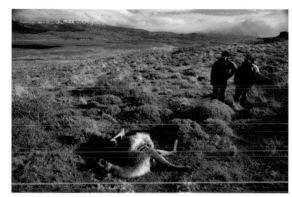

camera with an extra battery pack and set it to take a photo every 10 seconds. I put it inside the body of the guanaco, affixed it to the bones, and left. I returned a few hours later when the memory card was full. Back at my hostel, I reviewed the 750 pictures on the camera. No cougar. I repeated this process six more times. Still no cougar.

However, I had the joy of being able to capture an eagle feeding on the corpse. A perfectly framed moment. And I now have a collection of photos showing all kinds of raptors who take the time to clean the remains of the prey that the cougars leave behind. I take photographs to tell stories about life and death, and this picture captures both.

—KEVIN ZAOUALI

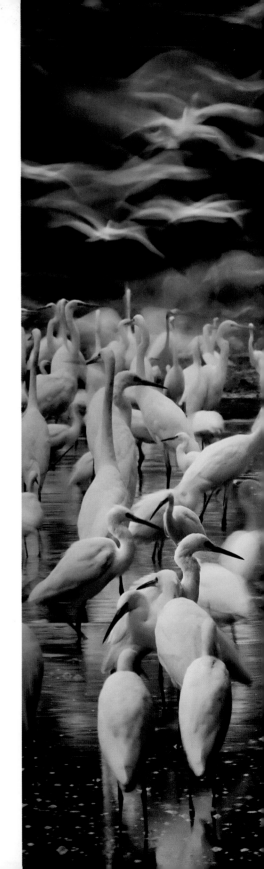

This amazing scene has an otherworldly, ghostly quality. These magnificent great egrets were nearly ghosts, in a sense, as the species was almost hunted to extinction more than a century ago. But egret numbers have rebounded tremendously in recent decades. To see hundreds of them gathering by the Danube is an exciting sight, which we can celebrate as a great success story in our global effort to sustain life on Earth.

—JACK DUMBACHER, CURATOR OF BIRDS AND MAMMALS AT THE CALIFORNIA ACADEMY OF SCIENCES

Flight of the Egret
Zsolt Kudich

Great egret (*Ardea alba*)
Gemenc Forest, Danube-Drava National Park, Hungary

More than 1,000 great egrets find sanctuary on a dry lake bed, temporarily flooded by the Danube's overflows. This elegant species has dramatically recovered since the late 19th century, when hunters killed the birds for their showy and fashionable breeding feathers. A hunting ban and other protections, such as the preserve at Gemenc, helped. Kudich captured this dawn spectacle with a slow shutter speed and large depth of field. "The egrets aloft resemble foamy clouds," he says, "while those standing on the ground motionless have sharp silhouettes."

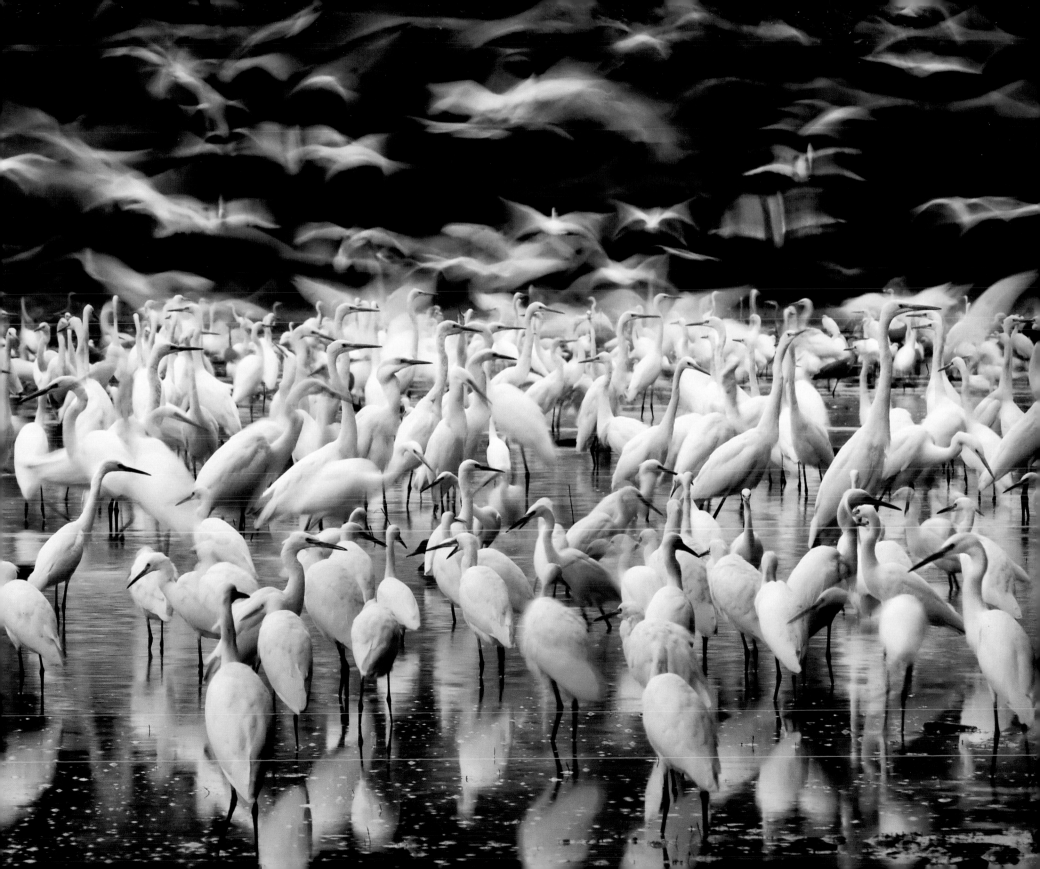

Gotcha!
C. S. Ling

Malabar pied hornbill (*Anthracoceros coronatus*)
Jewel beetle (*Buprestidae*)
Udawalawe National Park, Sri Lanka

Native to tropical southern Asia, Malabar pied hornbills face pressure from deforestation. Ling caught this one as it tossed a beetle toward the back of its throat before swallowing.

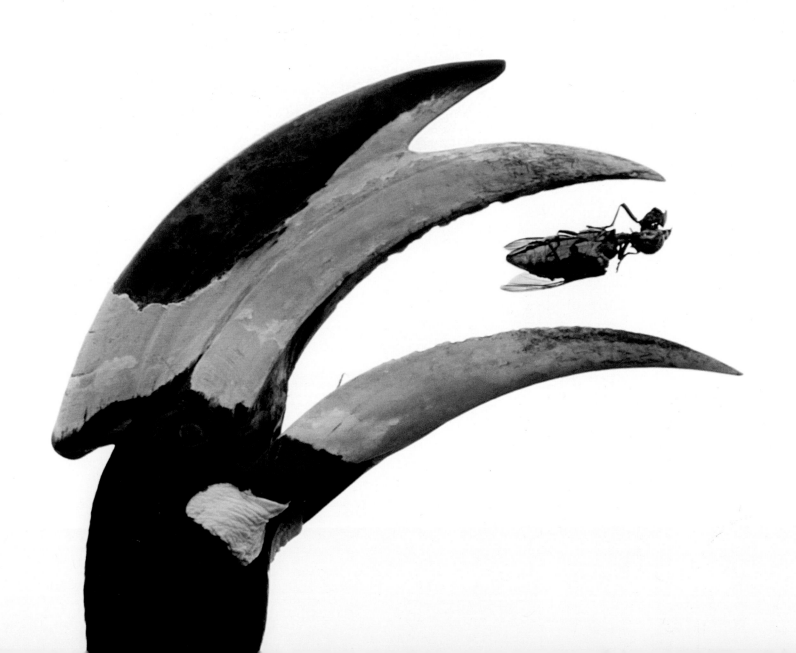

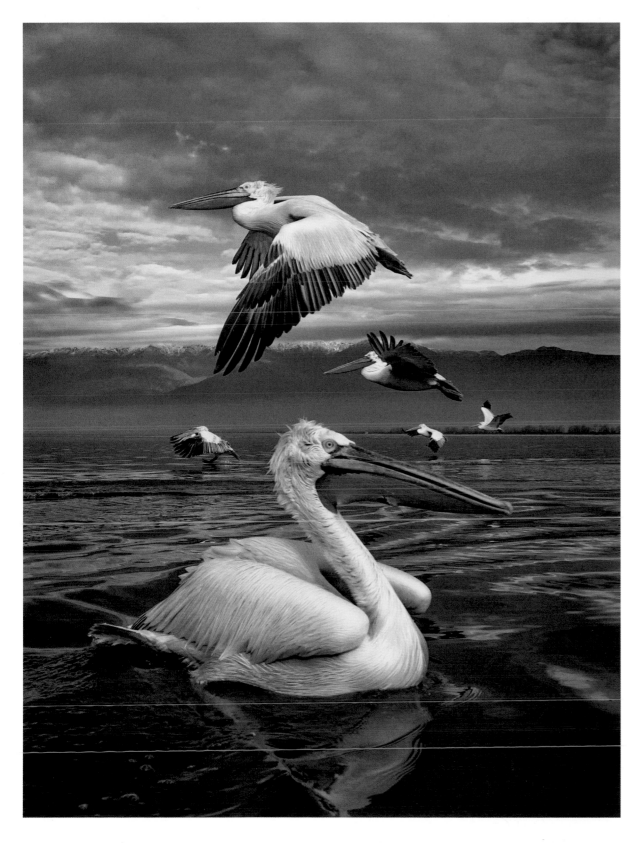

A fraction of a moment later, and this image might not work. Marco Urso's patience and foresight freeze the one second when every element is where it should be. The hint of color against a complementary backdrop provides a perfect finish.

—NEIL EVER OSBORNE, CONSERVATION PHOTOGRAPHER AND BIGPICTURE COMPETITION JUDGE

Birds in Line
Marco Urso

Dalmatian pelican (*Pelecanus crispus*)
Lake Kerkini, Greece

Lake Kerkini, an artificial reservoir in a national park in northern Greece, is a bird-watching mecca. It provides an important wintering area in Europe for the Dalmatian pelican, a huge yet vulnerable bird species. "I wanted to show how pelicans fly," says Urso. "There were plenty of pelicans, but the challenge was to compose them." He waited more than an hour for the birds to line up for the perfect shot.

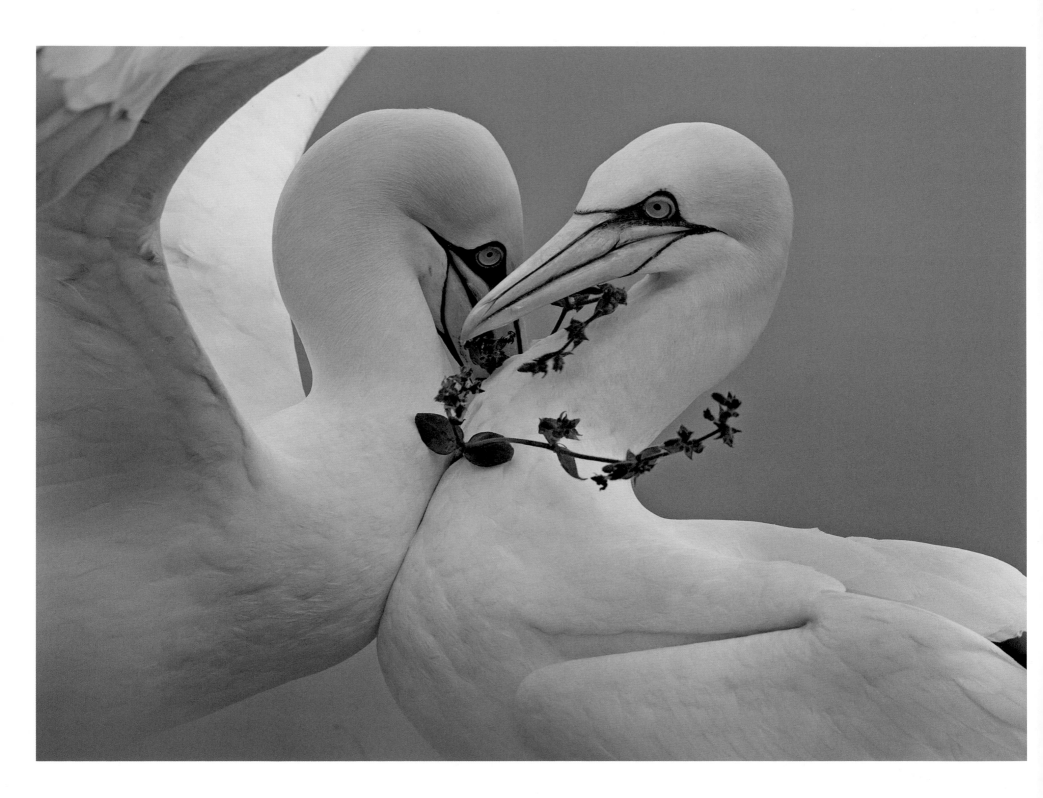

True Love
Steve Race

Northern gannet (*Morus bassanus*)
Bempton Cliffs, East Yorkshire, England

Northern gannets pair for life, returning to the same nest site each year to breed. Race recalls, "Many times, I have seen the male offer the female a gift, from feathers to grass. To my amazement, this individual offered its partner a necklace of red campion."

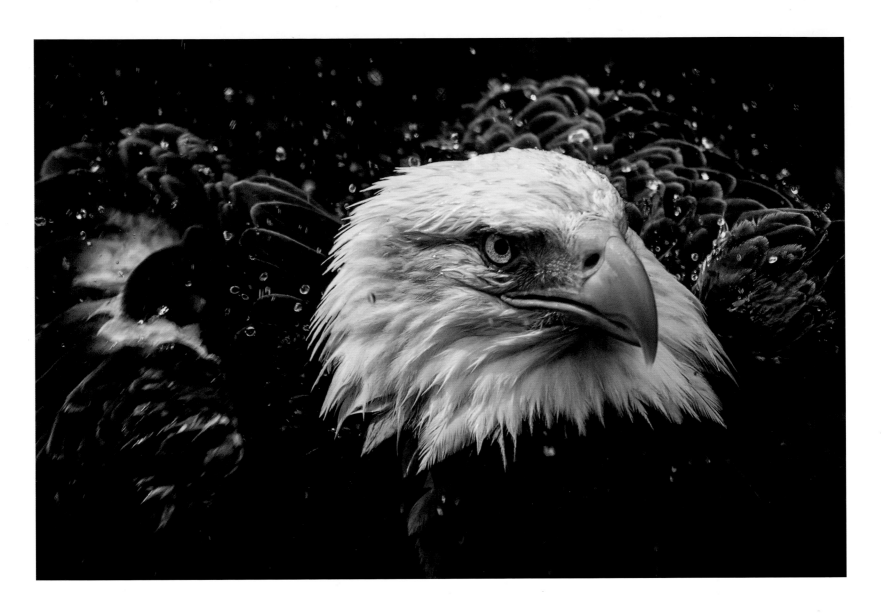

Shake It Off
Michael Pachis

Bald eagle (*Haliaeetus leucocephalus*)
Memphis Zoo, Tennessee, USA

In an epic comeback from near extinction, the bald eagle was removed from the endangered species list in 2007. Three rescued eagles, too badly injured to survive in the wild, found a home at the Memphis Zoo. As Pachis watched, one eagle "dunked his entire head in the water and came up shaking it off like a dog would."

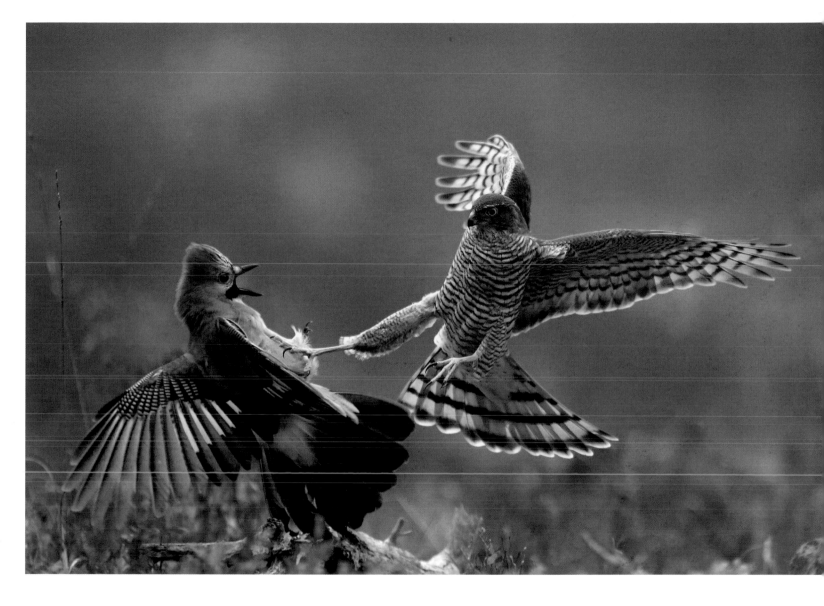

Great natural history images capture not only beauty but behavior as well. This photo tells a story and leaves the viewer wondering what happened next.

—CLAY BOLT, NATURAL HISTORY AND CONSERVATION PHOTOGRAPHER AND BIGPICTURE COMPETITION JUDGE

Attack
Pål Hermansen

Sparrowhawk (*Accipiter nisus*)
Eurasian jay (*Garrulus glandarius*)
Telemark, Norway

Sparrowhawks hunt using the element of surprise, darting out from a concealed perch or rapidly changing direction and seizing prey in their powerful talons. Hermansen shot more than 20,000 exposures to capture this swift "decisive moment" of attack.

BY **Suzi Eszterhas**

Photography in the Wild

Wildlife photographers are a strange breed. Most of us have been described as "driven," "passionate," or "focused." What people really mean is that we are eccentric—and quite possibly a little insane.

Ours is a bizarre profession. Our workplace is the natural world: outside, under the great blue sky or in the thickest, darkest jungles, where there are no controlled climates.

This job isn't glamorous. We torture our bodies: sleeping in strange places, carrying over 40 pounds of gear, tackling nature's obstacles. I've spent nights on a tropical desert island, in a mud hut, and in long grass with anti-poachers on an ambush. I've walked on floating logs in deep swamp water and climbed up cliffs through 60-mile-per-hour winds. Inevitably, we reach a point where the body seems to go on strike. So we turn to surgery to patch up joints and tendons. Then we go back to work.

Wildlife photographers are a resilient bunch. We might spend days or weeks searching for one animal. My record is 17 days. There was a jackal family whom I would get a little closer to each day, until I was finally in range to take my first photo. I then stayed with that family for five months, every day, from sunrise to sunset.

The people we work with in the field tend to be every bit as eccentric as we are. There's the guide who punched an attacking tiger in the face and humbly tells the story as if it were a walk to the market to get milk.

Or the game warden who accidentally shot himself in the chest, then hopped in his bush plane and flew himself to a city to reach a hospital.

Then there is, of course, our other community—the animals. To capture a truly unique perspective, you have to get close to a wild animal. There are two ways to do this, and neither is easy. The first: Disguise yourself to become invisible, dressing in head-to-toe camouflage, and blending into the natural environment. (Yes, it does look completely ridiculous.) The second: Earn the trust of the animals so they are comfortable with your presence. This can be one of the most challenging parts of the job as it involves patience and endurance. Once, I hunkered down in the same twisted position for 13 straight hours, and had to worry about confusing my pee bottle for my water bottle—a one-time-only mistake.

Approaching the subject slowly—so that it's not alarmed or stressed—is not only critical to creating great imagery, but is also one of the most important ethical issues in wildlife photography. Any time an animal allows me to be in its presence, I am deeply grateful for the privilege.

As wildlife photographers, we let nature take its course and don't intervene. But we can't help getting emotionally involved. After all, we might spend months with the same animals. We root for our

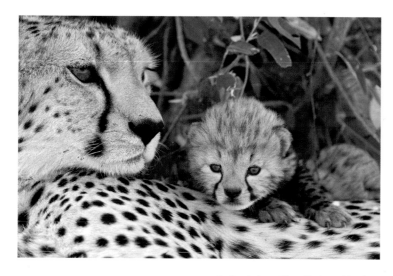

A cheetah and her 17-day-old cub photographed by Suzi Eszterhas at the Maasai Mara Reserve in Kenya.

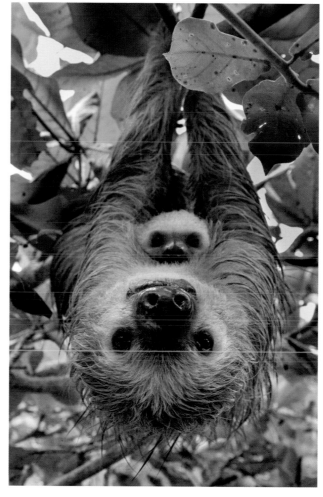

A two-toed sloth and her two-month-old baby hanging out at the Sloth Sanctuary in Costa Rica, photographed by Suzi Eszterhas.

subjects as we watch the drama unfold. In the process, it can break our hearts. I have cried for days over the demise of an entire litter of five beautiful cheetah cubs. I have laughed out loud watching a grizzly bear throw a temper tantrum. And I have screamed in anger at hyena cubs who decided to chew up my car engine.

I wish I could say I love all the animals on Earth. But that would be a lie. I wasn't particularly fond of the insects that laid eggs in my feet. Or the tick that attached itself deep inside my nostril. Or the various parasites that have set up shop in my stomach.

It's a strange—and utterly fascinating—job, this profession of wildlife photography. On days when I'm in the office, sitting in front of my computer editing images, I dream of being out in the field. Animals are wild and unpredictable. And every day spent with them is a new adventure: big and wide, open and free. I can't imagine doing anything more rewarding.

Suzi Eszterhas is an award-winning wildlife photographer best known for documenting newborn animals in the wild. Her photographs have been published in numerous books and hundreds of magazine stories. A dedicated conservationist, Eszterhas lends her images and expertise to raise funds and awareness for environmental organizations around the globe.

To capture a truly unique perspective, you have to get close to a wild animal.

On Land

We tend to think of
charismatic wildlife as the large
four-legged mammals who live in the jungle, savanna, or snow. But terrestrial life ranges
from the most magnificent rhinoceros to the tiniest termite.
Many land-dwelling animals are close to home, if not right in the
home. With skill, a photographer can find a jumping spider
hidden in pineapple leaves and produce an exceptional image
of an arthropod that exudes charisma.

More often, though, the photographer is out in the field or,
rather, concealed in a photo hide, awaiting the moment when
the animal emerges, meets its adversary, or makes eye contact.
And later we get the benefit of empathy for that individual
monkey, without the peril of proximity.

Remarkable photographs capture the essence of animal
behavior or movement. That can be a challenge when the
movement is an all-weather odyssey across Africa. During the
Great Migration, which has been described as the greatest
wildlife spectacle on Earth, over a million wildebeests and
hundreds of thousands of zebras and gazelles race across the
Serengeti. Two very different photographs capture and compose
the chaos. One plunges the viewer right into the midst of the
zebra herd. The other takes a distant view, not just spatially but
also temporally, evoking a painting on a cave wall, with the
aptly named wildebeest leading the herd in classic form. Both
are dramatic portraits of earthbound lives.

I like the surprise of seeing a macaque outside of the hot springs. With the soft background palette and the shock of that red face, it feels like the macaque is three-dimensional, ready to walk out of the frame. For me, this is a really simple photograph, all about tonality.

—KATHY MORAN, SENIOR EDITOR FOR NATURAL HISTORY AT *NATIONAL GEOGRAPHIC* MAGAZINE AND BIGPICTURE COMPETITION JUDGE

Monkey in the Snow
Jasper Doest

Japanese macaque (*Macaca fuscata*)
Jigokudani Monkey Park, Nagano Prefecture, Japan

Every year, hordes of tourists flock to Jigokudani to snap shots of Japanese macaques soaking in hot springs. But these charismatic animals do have a life outside nature's Jacuzzi. Wanting to portray a fuller picture, Doest photographed the red-faced monkeys in their wintry mountain habitat. "This image takes me away into the alpine forest," he says, "and the eye contact with the monkey increases the empathy for this wonderful species."

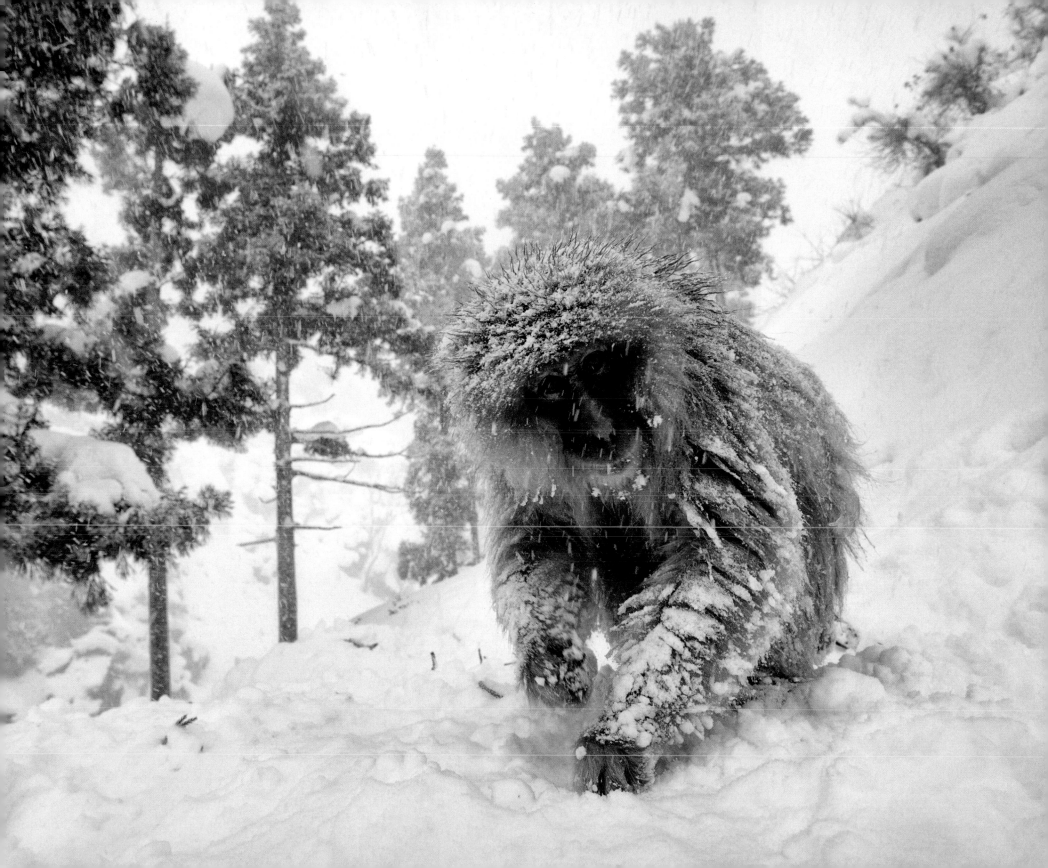

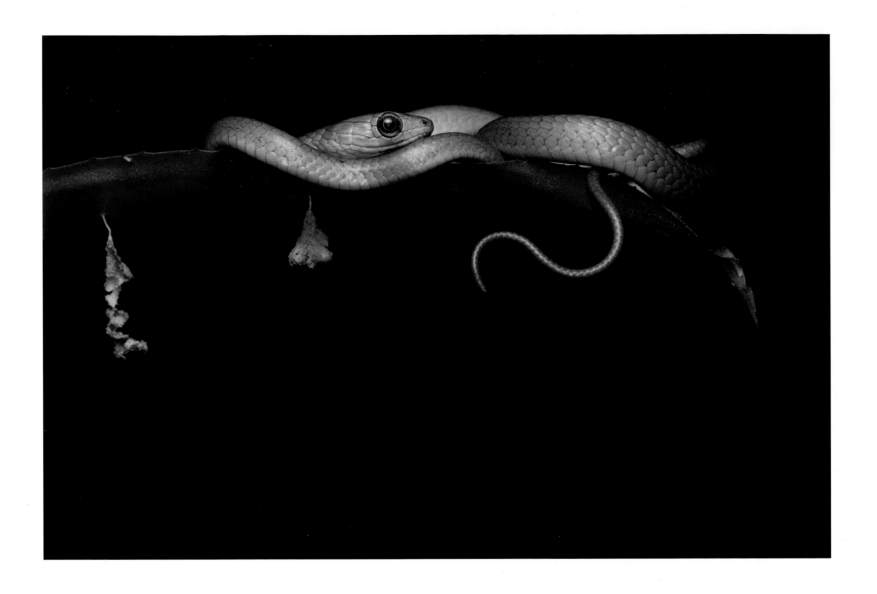

Young and Green
Jaime Culebras

Wagler's sipo (*Chironius scurrulus*)
Yasuni National Park, Ecuador

During a nighttime boating trip on a lagoon in Yasuni National Park, a vibrant color caught Culebras's eye. Under the full moon, he says, the juvenile vine snake "was the most incredible green I've ever seen."

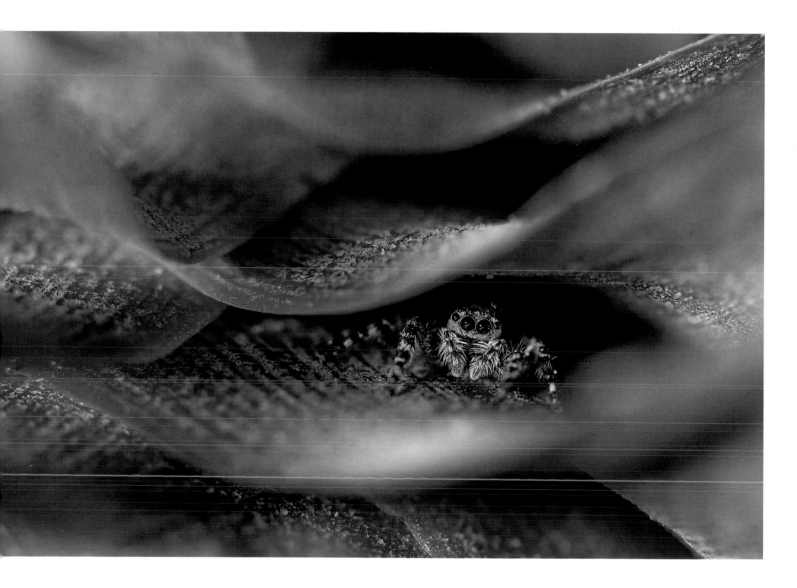

Male jumping spiders perform a lengthy courtship dance that coordinates visual cues with acoustic vibrations. We've only discovered one-third to one-half of all spider species. Many spiders you encounter in understudied regions have a high potential of being entirely new to science.

—LAUREN ESPOSITO, ASSISTANT CURATOR AND SCHLINGER CHAIR OF ARACHNOLOGY AT THE CALIFORNIA ACADEMY OF SCIENCES

The Houseguest
Kristhian Castro

Jumping spider (*Salticidae*)
Cali, Colombia

Jumping spiders often live around buildings, devouring insects. Castro noticed this one wandering about his house. Once he decided to take its photo, it posed within the leaves of a pineapple. "I felt like the spider did all the work," he recalls.

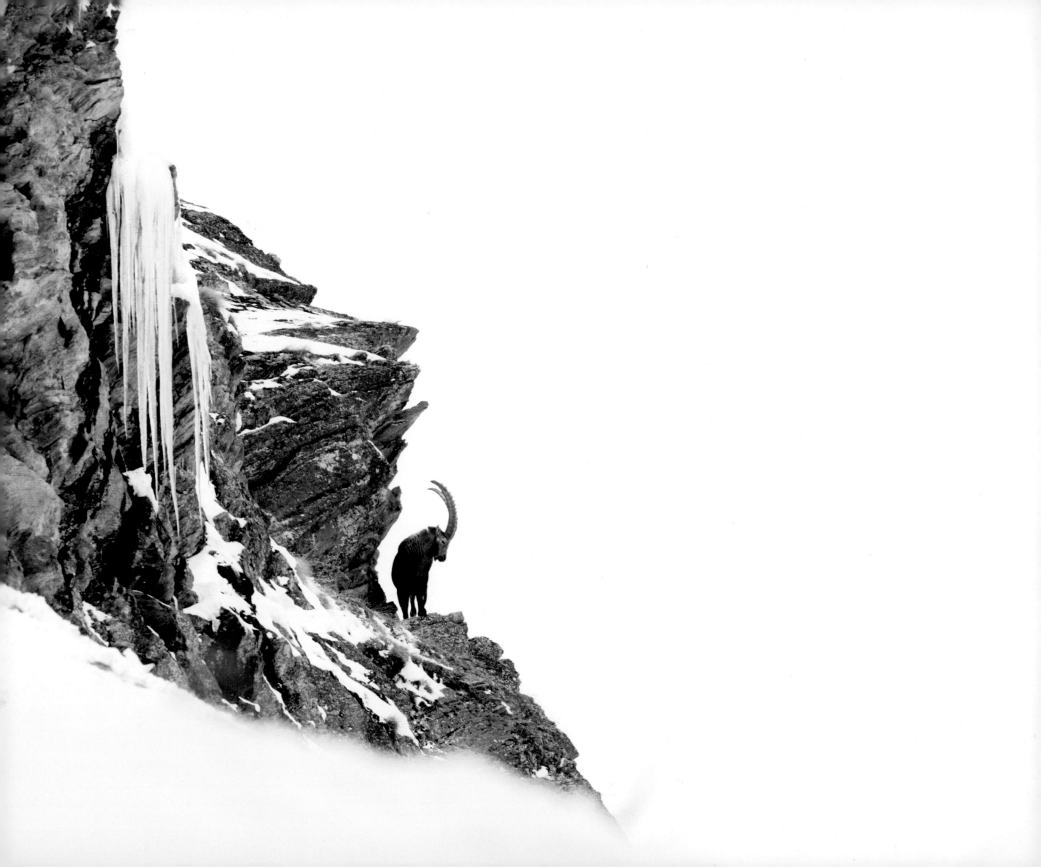

Elegant, simple, and absolutely beautiful. All the elements of artful composition, neutral space, positioning of the ibex, and the cascading icicles come together to make a stunning image.

—SUZI ESZTERHAS, WILDLIFE PHOTOGRAPHER AND BIGPICTURE COMPETITION JURY CHAIR

Curvy King
Emanuele Biggi

Alpine ibex (*Capra ibex*)
Gran Paradiso National Park, Valsavarenche, Italy

A herd of female ibex effortlessly darts over rugged terrain and up steep cliffs. A large male brings up the rear. For just a moment, he pauses on a crag and glances down, blending into the ice-covered cliffs of his winter home.

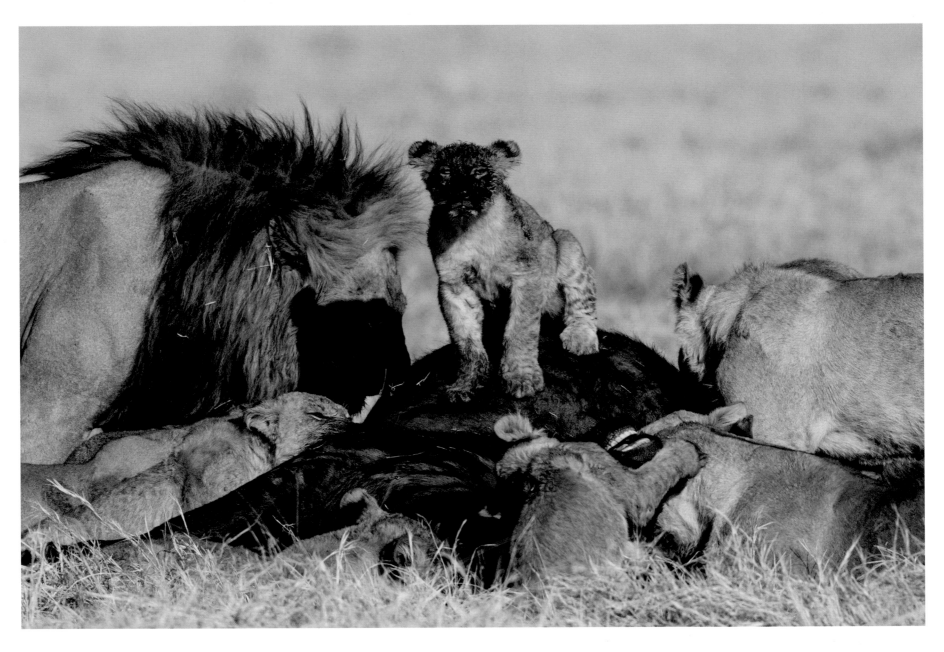

Natural Born Killer
James Gifford

Lion (*Panthera leo*)
Cape buffalo (*Syncerus caffer*)
Savute, Chobe National Park, Botswana

On an open marsh at Savute, a pride of lions feeds upon a buffalo whose face seems incongruously frozen in a grin—a striking contrast to the cub's bloodstained face and menacing stare.

Life in a Drop
Javier Aznar González de Rueda

Tree frog eggs and tadpoles
Chocó Rain Forest, La Maná, Ecuador

One rainy night, a mass of frog eggs dangled from
a bromeliad leaf. The photographer caught the
moment just before the hatching tadpoles fell into
the river below. With luck, these tadpoles would
grow into frogs.

A Rare Sighting
Sebastian Kennerknecht

Pampas cat (*Leopardus colocolo*)
Ciudad de Piedra, Bolivia

Only a handful of photos of the small Pampas cat in the wild
are known to exist. Kennerknecht's customized camera trap
snapped this image—one of only two pictures he got of the
wildcat during nine weeks in the Bolivian Andes.

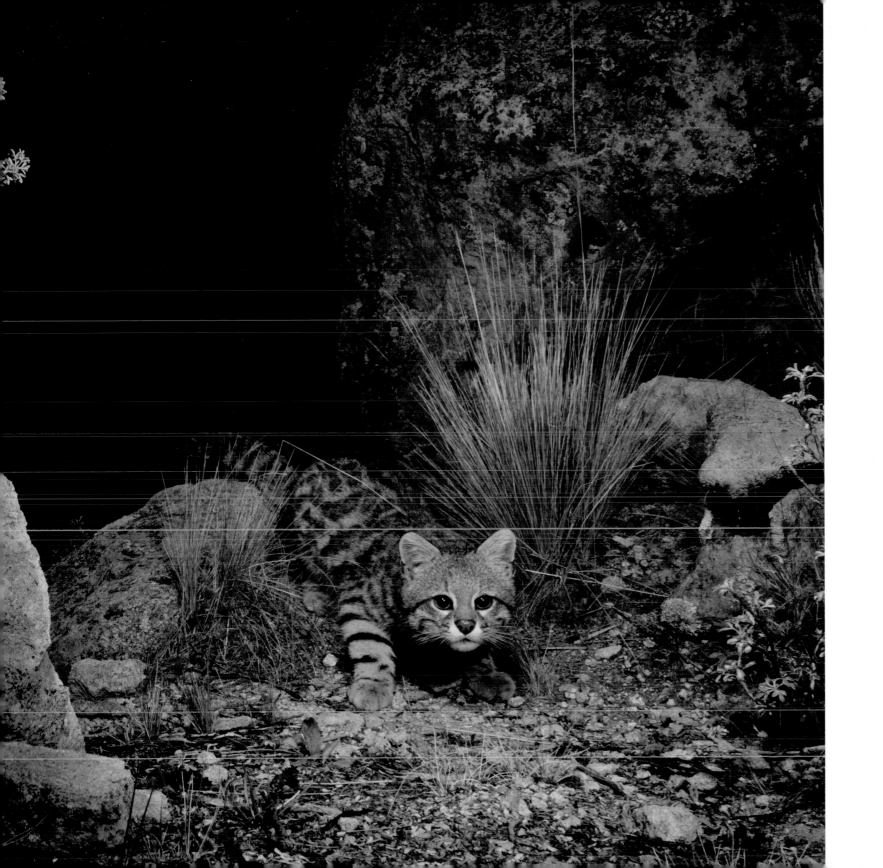

Planning, Persistence, and the Payoff

I am wild about wildcats—fanatical, actually. I especially care about the lesser-known feline species, mainly the smaller wild cats, of which there are roughly 31 species. High in the Andes Mountains live both the endangered Andean cat and the rare Pampas cat.

To get images of these mountain cats, I built digital SLR camera traps and set them up at locations above 13,000 feet in the Bolivian Andes. Working with biologists from the Alianza Gato Andino (Andean Cat Alliance) to figure out specific locations, I looked for entrances and exits to valleys where the cats hunted. Since it's possible to miss an animal by just a few feet, choosing the exact location for the camera traps was incredibly important.

This spot was ideal for a Pampas cat since it's a small funneling canyon leading out of a valley where the cats like to hunt.

Placing 30-pound camera traps in crevices while breathing the low-oxygen air of the high Andes was no easy task. Each camera would take a full day to set up—eight hours of hiking and three hours of setup. I set the power output on the flashes to overpower any ambient light, in order to properly expose the image during all parts of the day, and also to provide a glimpse of the amazing environment of the Bolivian Altiplano, the high plains of South America.

We came back to this spot the next day on our way to set up another camera trap. I had to check the camera: a Pampas

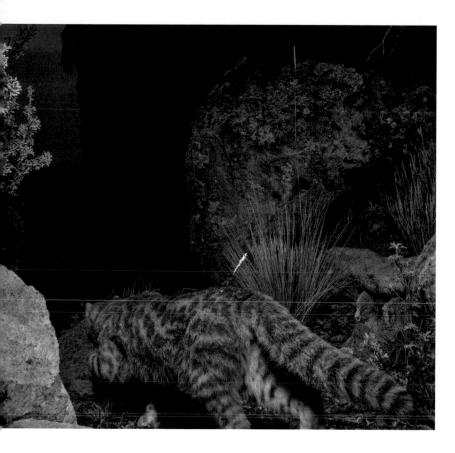

cat had come by! But it was walking away from the camera. Even after two weeks, all I had was that picture of a Pampas cat's rear end. Still, persistence is key with camera traps. Two more weeks passed with no results. Finally, with only two days left on the expedition, everything came together when this adult Pampas cat walked through the camera trap at night—this time walking the right way! I did a happy dance and gave a jubilant scream when I checked the camera that day.

I have taken two trips to the Andes, spanning a total of nine weeks, and this is only one of two pictures I have been able to get of this small wildcat. It shows how small this cat truly is, with the rock and grass towering over its 10-pound body. This image is special because it captures the personality of the Pampas cat, beginning with that low-crouched position and culminating in that specifically Pampas cat nose—that combination of caution and curiosity that we recognize in all cats large and small.

—SEBASTIAN KENNERKNECHT

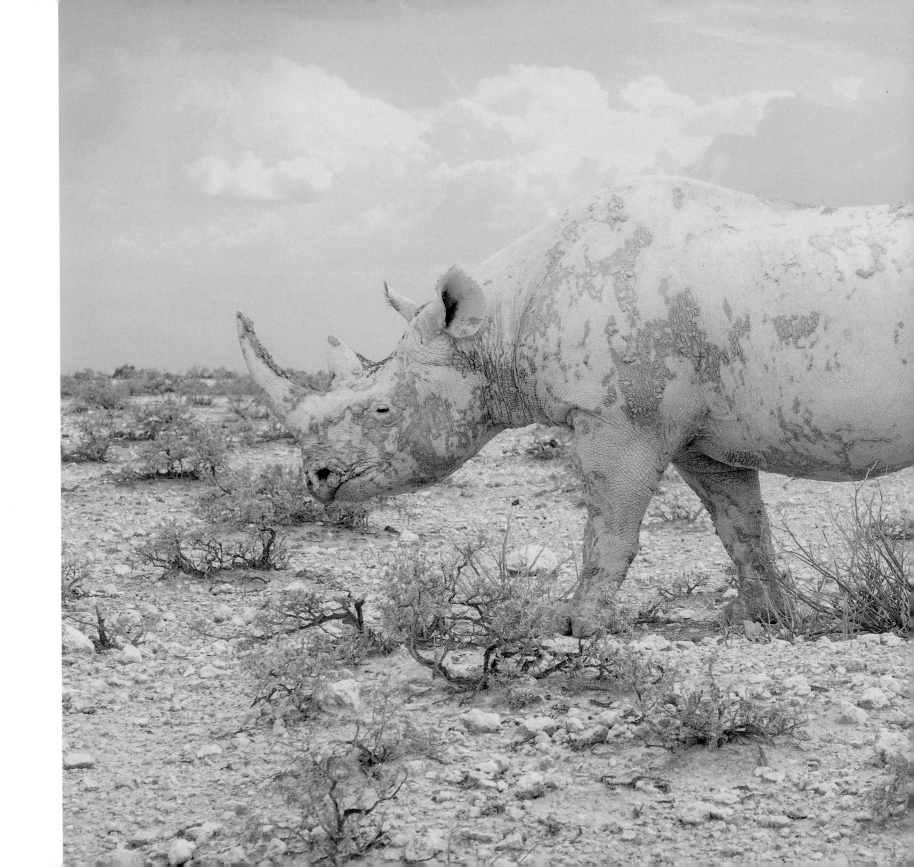

One of the most remarkable photographs I have ever seen. Not only does it show us a spectacular—and, sadly, incredibly rare—animal, it does so with the extraordinary backdrop of Namibia's salt flats and desert. In a single frame, we see a beautiful expression of life—even in this most arid, desolate place—and its relationship to landform and climate.

—DR. JONATHAN FOLEY, EXECUTIVE DIRECTOR AND WILLIAM R. AND GRETCHEN B. KIMBALL CHAIR OF THE CALIFORNIA ACADEMY OF SCIENCES

Camouflage
Maroesjka Lavigne

Black rhinoceros (*Diceros bicornis*)
Etosha Pan, Etosha National Park, Namibia

A solitary rhino greeted Lavigne as she drove along Etosha's parched salt pan, the remains of an ancient lake. White dust covered everything in sight, including the rhino, which was caked in dried mud. The image "feels and looks logical because of the different structures and colors that seem to go perfectly together," Lavigne says. It was an unforgettable close encounter with a magnificent yet threatened animal. "My heart felt like it was going to explode from adrenaline."

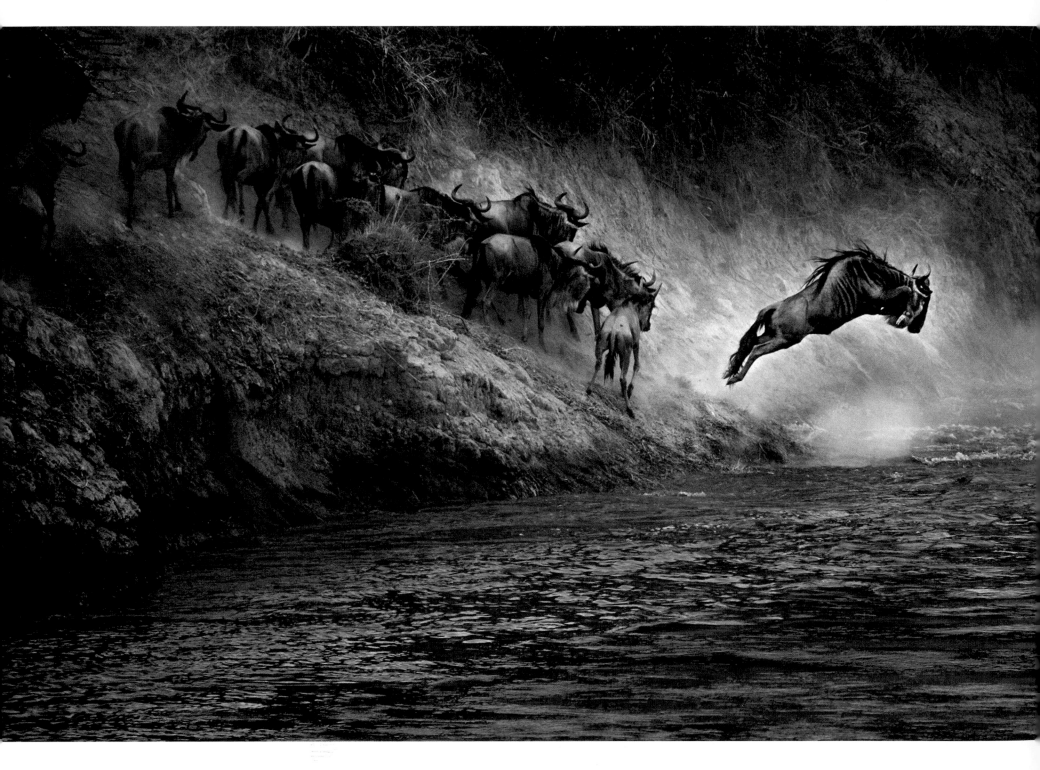

Leap of Faith
Scott Marmer

Wildebeest (*Connochaetes taurinus*)
Maasai Mara National Park, Kenya

During the Great Migration, more than one million wildebeests travel from Tanzania to Kenya. Leaping, stumbling, and swimming, they rush across the Mara River to avoid becoming a crocodile's next meal.

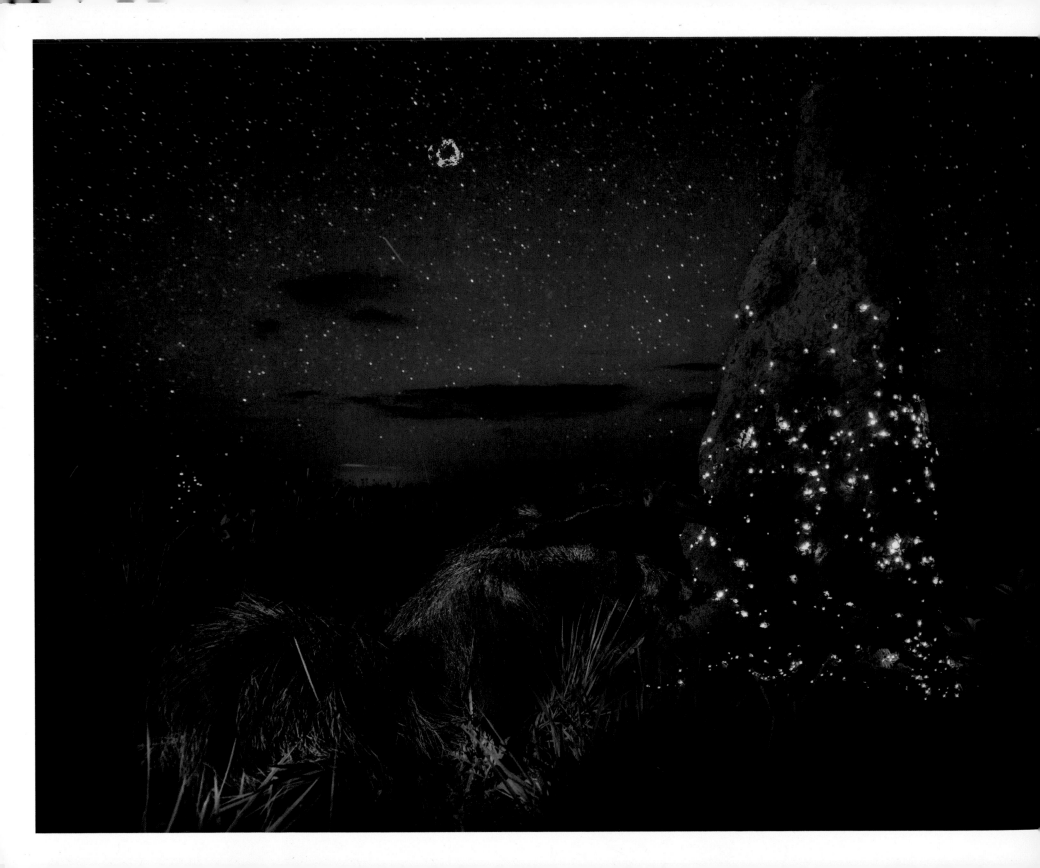

A brilliant result of technical mastery and artistry, this truly unique image captures the magic of the glowing termite mounds and the fascinating behavior of the mysterious giant anteater.

—SUZI ESZTERHAS, WILDLIFE PHOTOGRAPHER AND BIGPICTURE COMPETITION JURY CHAIR

Foraging Fest
Marcio Cabral

Giant anteater (*Myrmecophaga tridactyla*)
Click beetle larvae (*Pyrearinus termitilluminans*)
Termite mound (family *Termitidae*)
Emas National Park, Brazil

At the start of the rainy season, termite mounds in Emas National Park are festooned with glowing click beetle larvae, whose bioluminescence lures small flying prey. Termites, in turn, lure foraging giant anteaters, a threatened species. And all three players in this unique ecosystem attracted Cabral, who waited three hours one evening before this anteater appeared. The slow-moving mammals are common in the park, but "it is very difficult to observe them eating termites," he says.

Tiger Territory
Baiju Patil

Bengal tiger (*Panthera tigris*)
Tadoba National Park, Maharashtra, India

These magnificent tigers used to roam across most of
Asia. Now they persist only in pockets throughout the
continent. Protected by the borders of a sanctuary, two
tiger cub siblings jostle at Tadoba National Park.

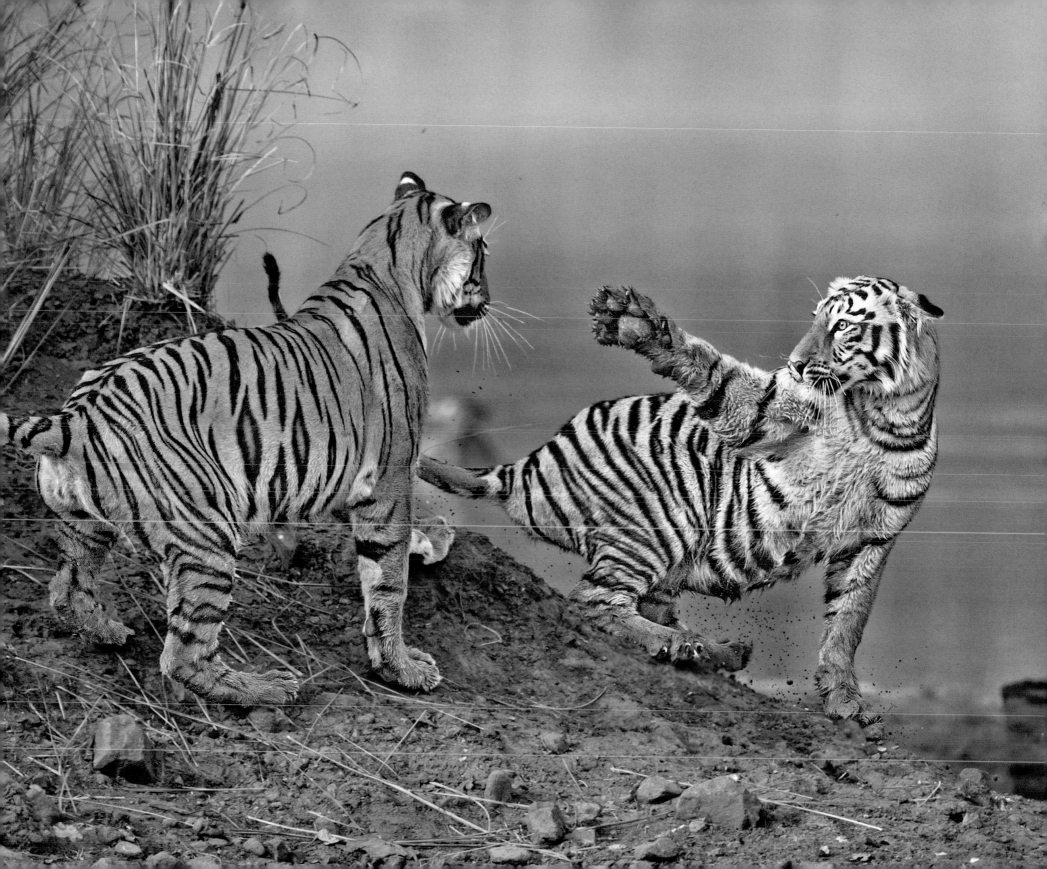

Simple and powerful. It's the kind
of image we should all strive for.

Snow Mountain
Ray Collins

Wollongong, New South Wales, Australia

Collins seeks to document the ocean's many moods. On
this day, he tucked his camera safely in its water housing
and jumped into the waves. Fish swam underneath him,
and birds crisscrossed the sky above. A swell began to
form on the horizon—driven by wind and rising with the
morning sun.

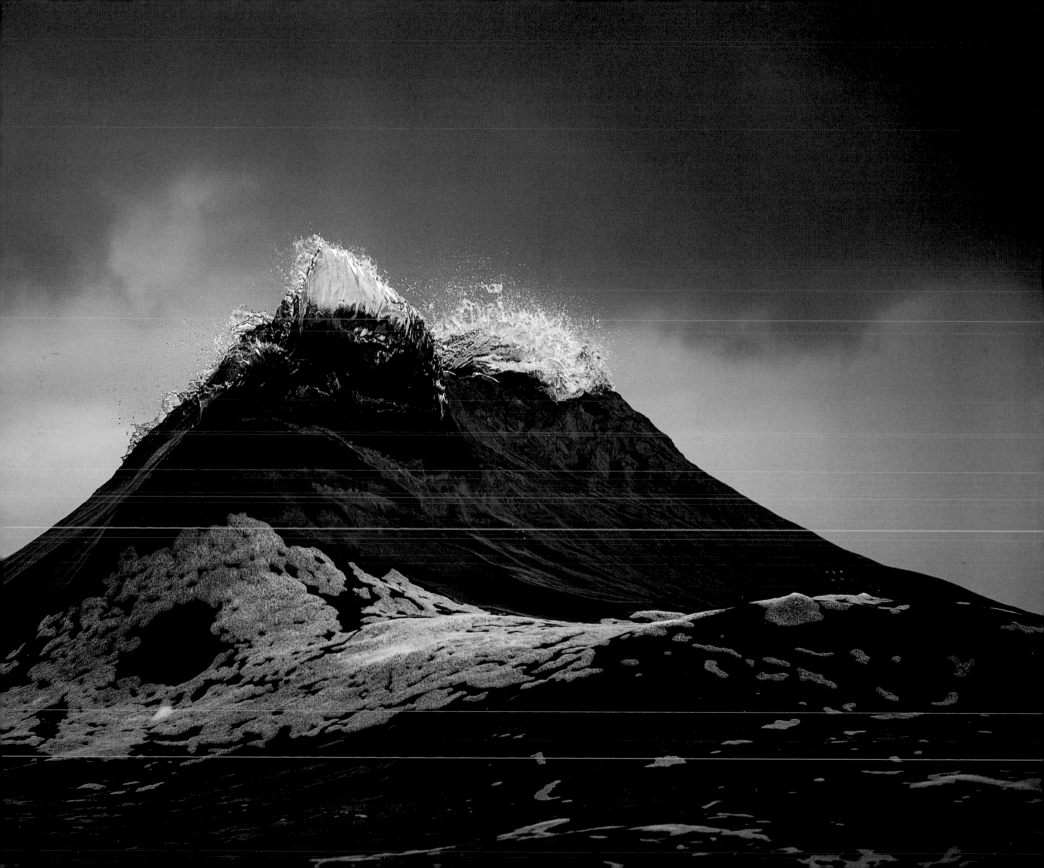

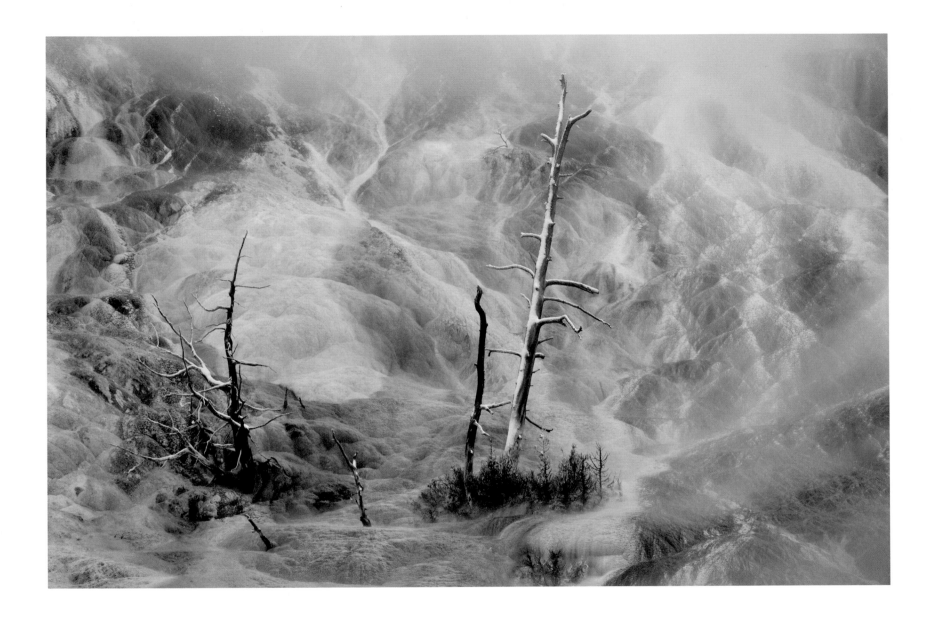

Mammoth Dream
Connor Stefanison

Mammoth Hot Springs, Yellowstone National Park, Wyoming, USA

On a frigid New Year's morning, mist whirls above a scalding geothermal pool. Algae and cyanobacteria that tolerate this extreme heat add color to the surface of the rock, creating an otherworldly landscape.

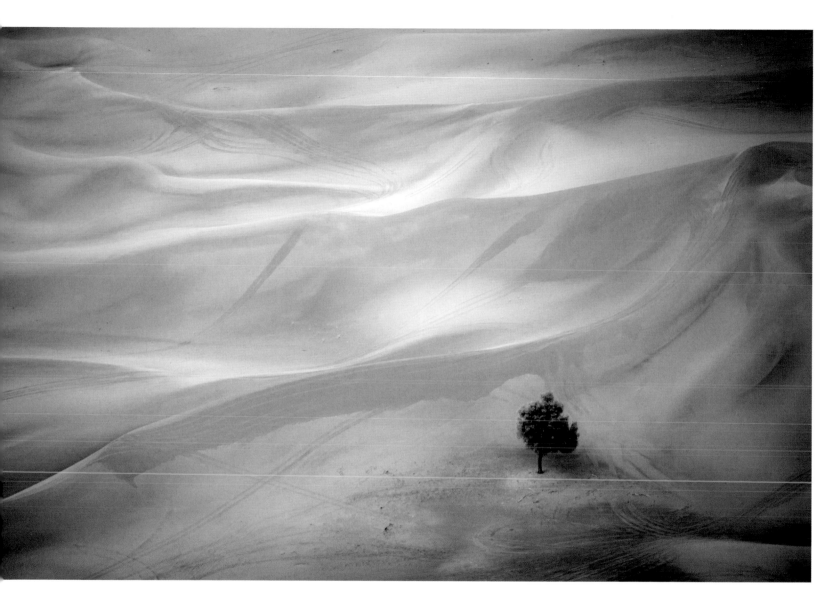

This image is a stunning reminder of the resilience of nature. A beautiful composition, both artistically as well as in its message.

—IAN SHIVE, CONSERVATION PHOTOGRAPHER, AUTHOR, FILM PRODUCER, AND BIGPICTURE COMPETITION JUDGE

Survivor in a Sea of Sand
Mark Seabury

Athel tamarisk (*Tamarix aphylla*)
Dubai Desert Conservation Reserve, United Arab Emirates

Seen at sunrise from a hot air balloon, the undulating dunes of the Dubai desert almost come alive with motion. "The waves are created through the effects of the wind, and the patterns and textures are highlighted through the play of light," Seabury says. In this vast sand sea, a single athel tree appears "as a steadfast symbol of life in impossible conditions."

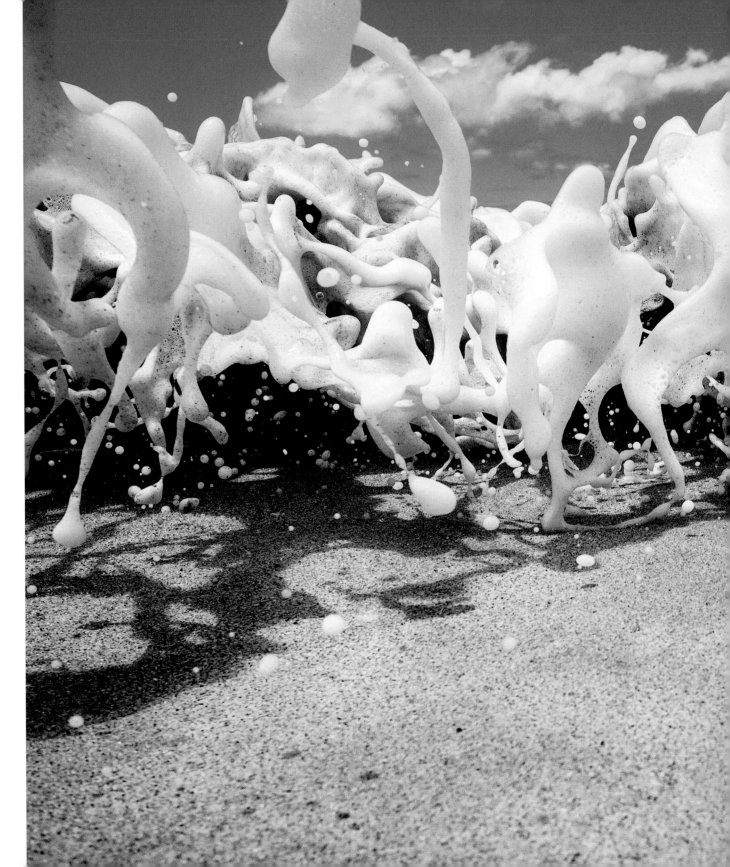

Cappuccino
Giuseppe DeMasi

Oahu, Hawaii, USA

A surrealist view of dancing seafoam, frozen in time and space. To capture this moment, DeMasi lay beside a 10-foot-high sandbank, waited to click the shutter as a wave came in, and then was swept up the beach.

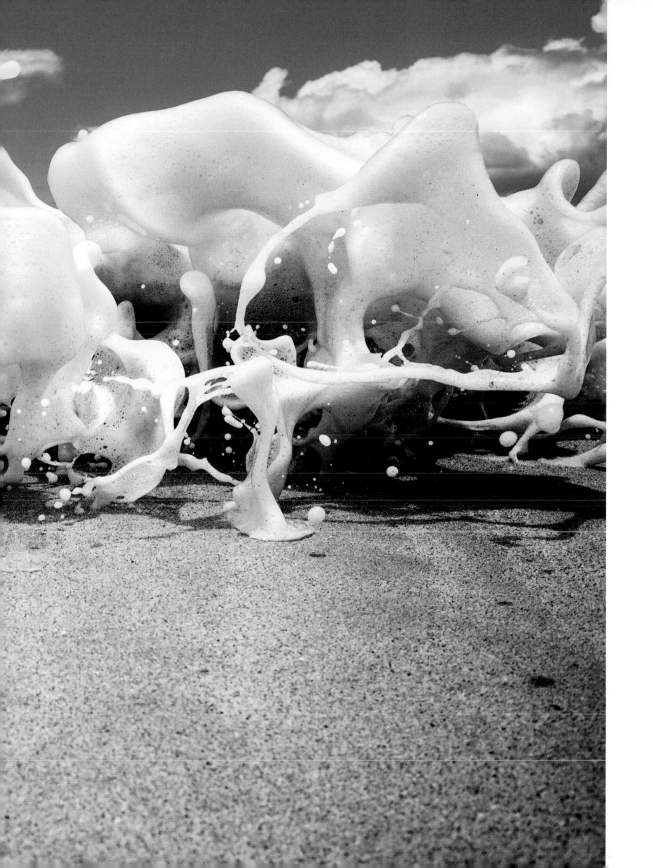

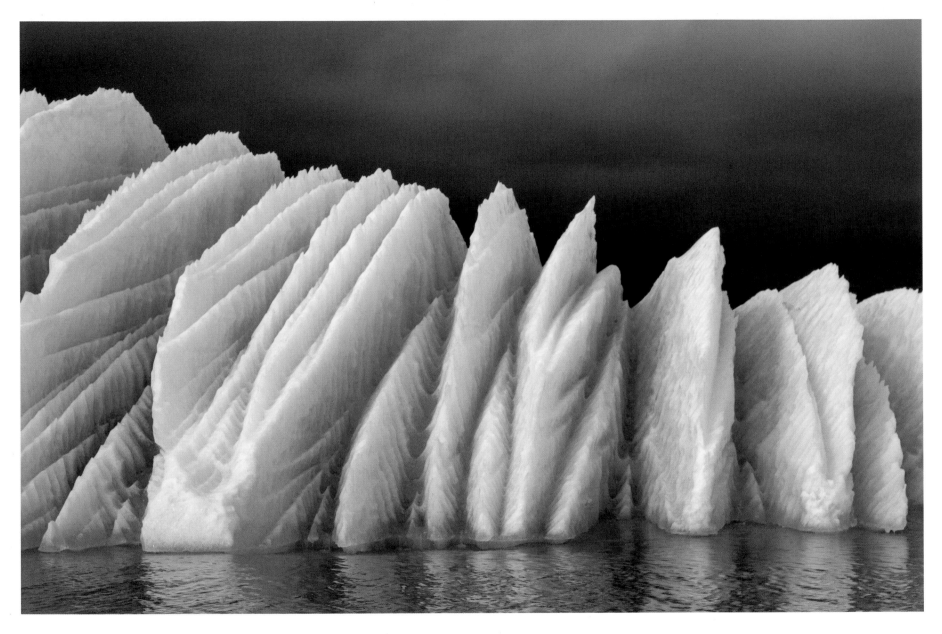

Jökulsárlón Iceberg
Milko Marchetti

Jökulsárlón, Iceland

Behind this jagged iceberg, floating in Iceland's Jökulsárlón Lagoon, a storm is brewing. As the glacier that created this lake retreats and melts, Jökulsárlón has increased fourfold in the last 40 years, recently becoming the country's deepest lake.

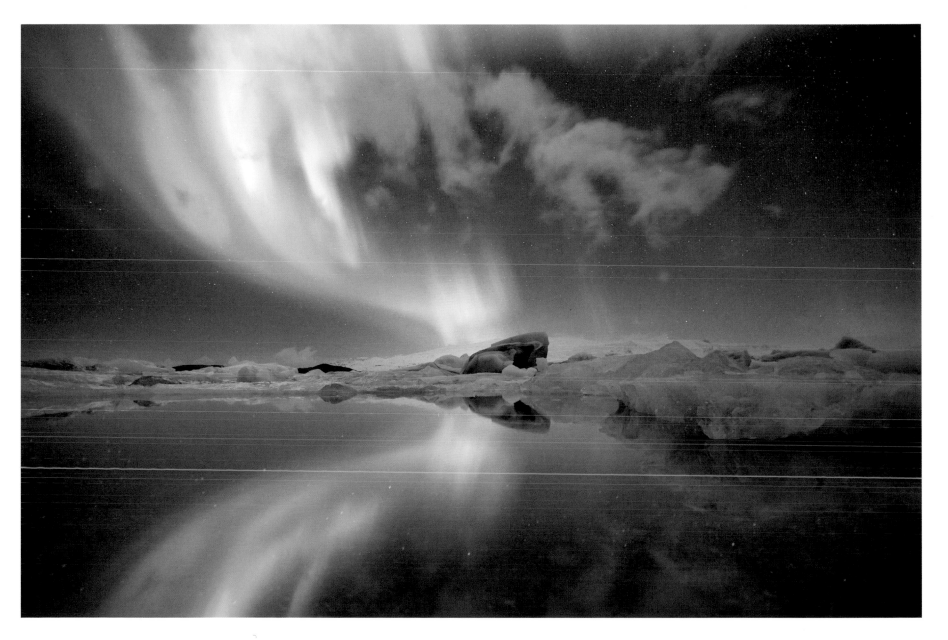

Aurora over Lagoon
Josh Anon

Jökulsárlón, Iceland

The forecast looked bad for spotting auroras—it had been storming all night. About to give up, Anon watched the sky suddenly clear. Above this remote corner of Earth, swirling green lights slowly rolled into red.

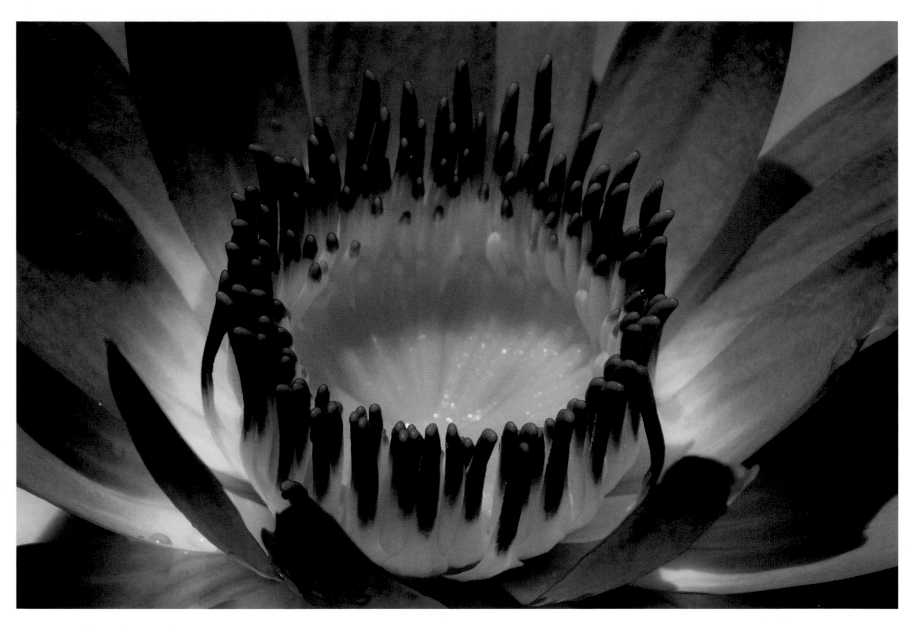

Egyptian Sacred Lily
Dick Lavine

Water lily (*Nymphaea caerulea*)
Austin, Texas, USA

Native to northern and central Africa, the sacred blue lily symbolized creation and rebirth for the ancient Egyptians. While it has all but disappeared from the Nile Delta, it can be spotted at Austin's Zilker Botanical Garden, where Lavine is a frequent visitor.

Magic on the Highlands
Marcio Cabral

Sempre-viva (*Paepalanthus polyanthus*)
Chapada dos Veadeiros National Park, Brazil

The sempre-viva ("live-forever") is a rare wildflower
native to central Brazil's highlands, a biodiversity
hotspot. The blooms reflect light in an unusual way.
Glowing against a dramatic cloudscape, they make
"a great spectacle of nature," Cabral says.

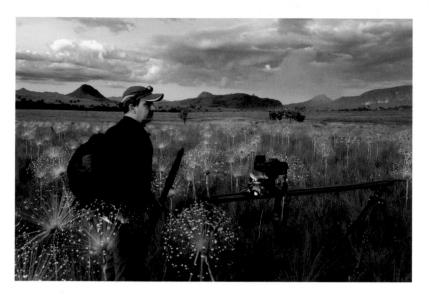
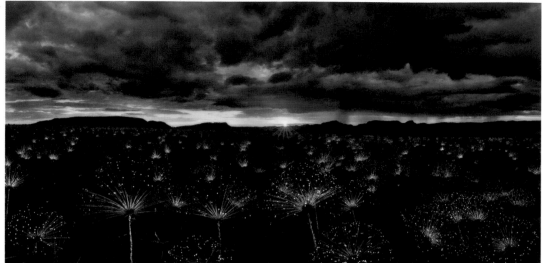

Seeing the Light

In the savanna of a national park in Brazil lives the rare and beautiful wildflower called the Paepalanthus. Its common name, sempre-viva, translates to "live-forever." But this flower comes most alive at sunset, when I took most of these photographs. At this time the flower is backlit and reflects the light, generating an interesting glowing effect. It is my favorite wildflower, so I have studied the best sites and times of the year to photograph

it. I study the weather and cloud formations before entering the Cerrado (Brazilian savanna). The wind is a challenge because it can blur the image, so you have to be patient to get a good shot.

Our presence attracted many blood-sucking mosquitoes, especially at sunset. Repellents are ineffective with these mosquitoes, so I need mosquito nets, long clothing, surgical gloves, and leggings to protect me. In fact, there were a few

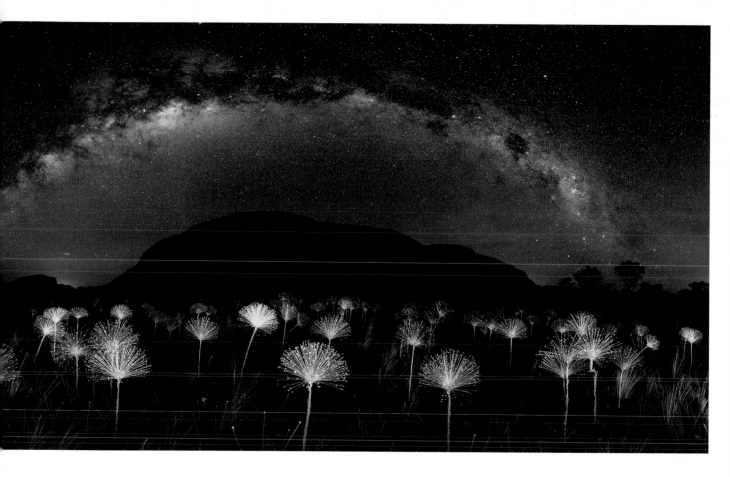

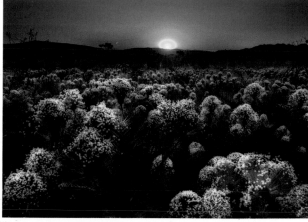

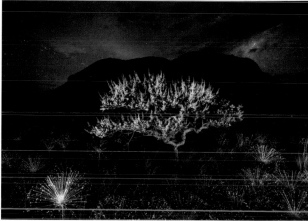

photographers who were attacked by the mosquitoes and had to leave quickly because they did not have adequate clothing and protection.

These photographs were taken in Chapada dos Veadeiros National Park, a protected UNESCO site in the Goiás state of Brazil, and one of the oldest and most diverse ecosystems in the world, known for its huge waterfalls and billion-year-old rocks.

—MARCIO CABRAL

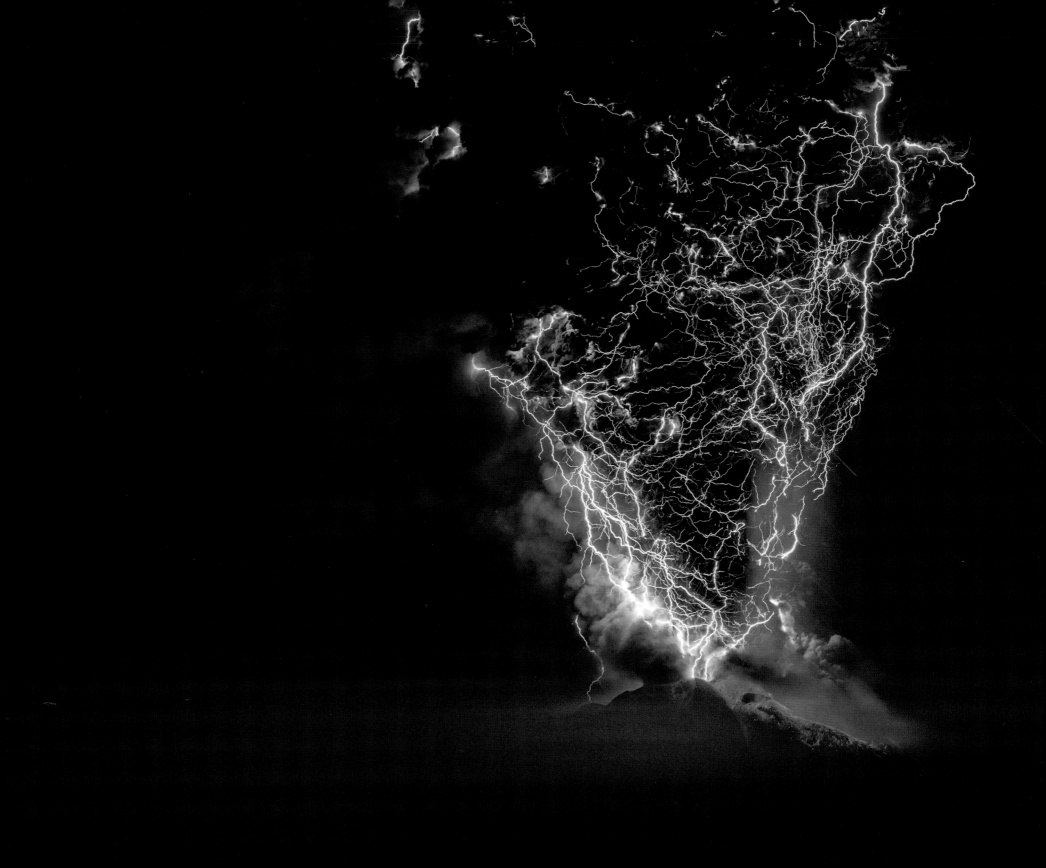

Francisco Negroni's image is a truly electrifying reminder of nature's raw power, fully unleashed. I'm awestruck by the artist's technical prowess. The volcano hadn't erupted in decades, which means he was reacting to a quickly changing situation.

—IAN SHIVE, CONSERVATION PHOTOGRAPHER, AUTHOR, FILM PRODUCER, AND BIGPICTURE COMPETITION JUDGE

The Awakening
Francisco Negroni

Calbuco volcano, Los Lagos Region, Chile

After decades of dormancy, Calbuco volcano erupted on April 22, 2015, prompting thousands to evacuate the area. Negroni set up his tripod at an elevated spot nearby and used a long exposure to photograph nature's explosive fury at its zenith—with funnel-shaped lightning descending and ejected magma reaching gigantic heights. "It was a landscape of fear that wowed me with unspeakable violence," he says.

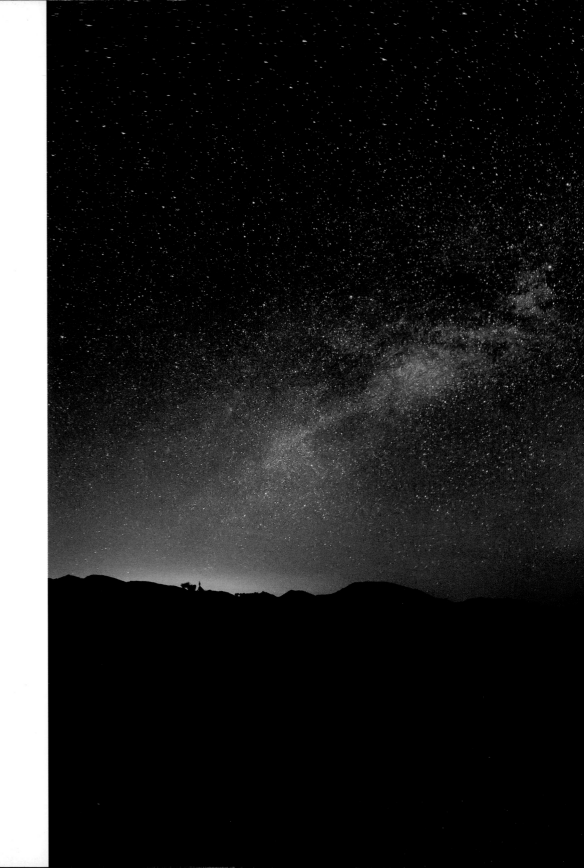

Heaven and Earth
Manish Mamtani

Joshua tree (*Yucca brevifolia*)
Joshua Tree National Park, California, USA

The Milky Way arches in timeless harmony over a
Joshua tree. Yet down here on Earth, desert national
parks are losing stands of this normally long-lived
yucca plant due to wildfires brought on by drought.

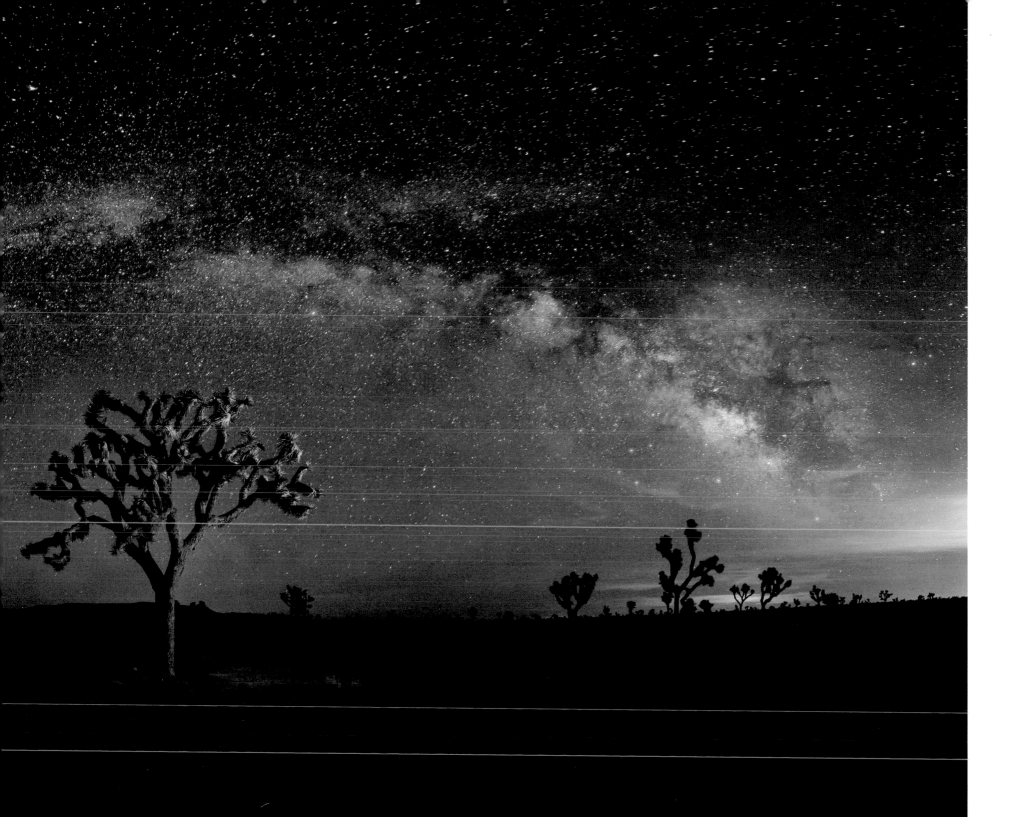

Cloud Island
Shane Kalyn

Tumuch Lake, British Columbia, Canada

On a calm day, a flight over Tumuch Lake's mirror-like surface reveals a world turned upside down. "As we flew by this island," Kalyn recalls, "it truly looked as if it was floating in the reflected clouds."

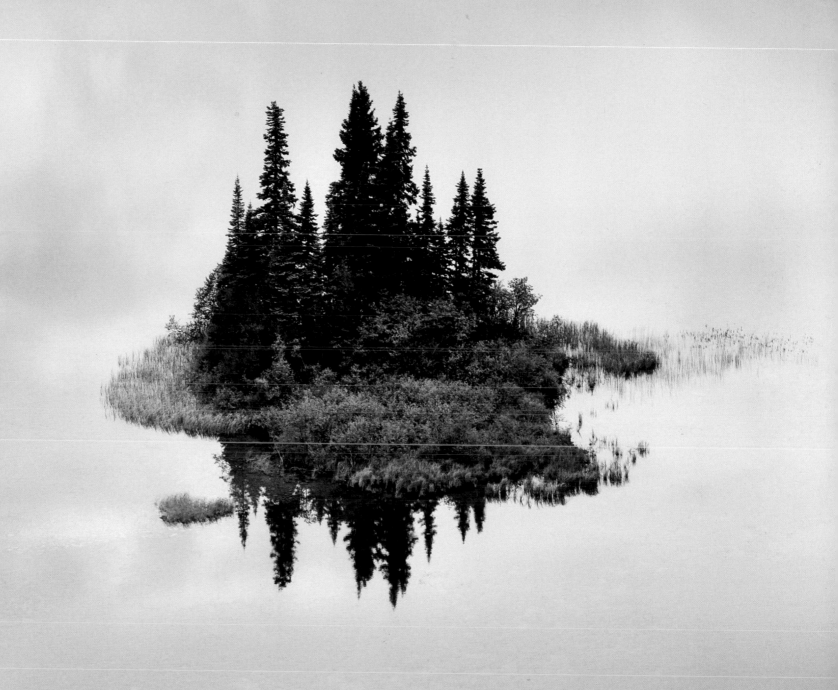

BY **Dr. Jonathan Foley**

A Wondrous World Revealed

To me, the most truly human thing we can ever do is experience the wonders of the natural world and share them with the people we love.

Consider this: Before the evolution of the human mind and the emergence of human culture and art, Earth was a remarkable planet, but a planet governed only by the rules of physics, chemistry, and biology. An extraordinary spot in the solar system, to be sure, but one that was not yet fully conscious of itself.

Until we came along, Earth did not have aware *minds*, who created art, sharing our sense of beauty and joy with loved ones, strangers, and even future generations.

Today Earth is filled with human beings who are conscious, creative, reverent, and in awe of its beauty. We are compelled to preserve and share this beauty, even with people we may never meet, through museum galleries, aquariums and botanical gardens, or nature documentaries. Or through a beautiful book of photographs, like the one you are holding now.

The powerful photographs selected for this volume illustrate some of the many marvels of our world. Photographs show us that Earth's oceans hold magnificent coral reefs, beautiful marine cities bustling with life, sparkling through cerulean waters. Straddling the equator, tropical rain forests teem with a riot of life, and photographs delight us with the amazing creatures and extraordinary vistas these forests hold. Photography can transport us to Earth's extreme deserts and polar regions, revealing the Spartan beauty of nature and the toughness of life that has adapted to these harsh environments. Photographers show us extraordinary grasslands and savannas across many continents, each filled with inspiring animals that have captured our imaginations since childhood.

If we are very, very lucky, we might experience some of these natural wonders in person. But we cannot possibly see them all. Even if we did, the memories would be fleeting.

Thankfully, the power of photography can transport all of us at any time to these extraordinary places, to see these remarkable moments, all through the eyes of an artist. And these images can be easily shared with friends, strangers, and even future generations. Outstanding nature photographs, like those in this volume, can stir the mind and awaken our hearts and souls. Truly great photographs endure far beyond our time, and inspire generation after generation of nature lovers. Who doesn't still marvel at the elegant beauty of Ansel Adams's remarkable images?

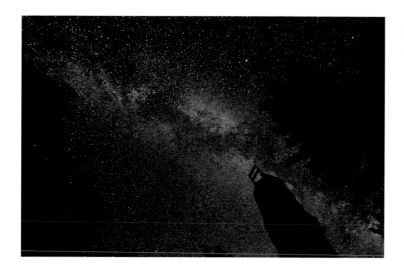

Behind the remains of an old tree hit by lightning (and adorned with a chair) is the Milky Way galaxy as seen in the Northern Hemisphere summer and photographed by Dr. Jonathan Foley in the Muskoka Lakes region, Ontario.

Great photography is more art than science, more magic than method. I hope that this book rekindles our deep appreciation of the natural world, reminding us of our necessary connection to the rest of the biosphere—and that (whether we like it or not) we must share this world. Everything and everyone we know, everything we have ever been, everything we are, and everything we will ever be, will take place on this remarkable world.

As you look at the astonishing images in this volume, recall they are all taken from the same place—the same small, wondrous world of rock, water, and life, all hurtling around the same star in space. And what a world it is. Thankfully, these photographs will help us know and love it a little bit better.

Dr. Jonathan Foley is a world-leading environmental scientist and author, and has worked on numerous issues including climate change, global land and water use, and sustainable agriculture. Today, he is executive director and William R. and Gretchen B. Kimball Chair of the California Academy of Sciences, where he is focused on public engagement and education around sustainability and the global environment.

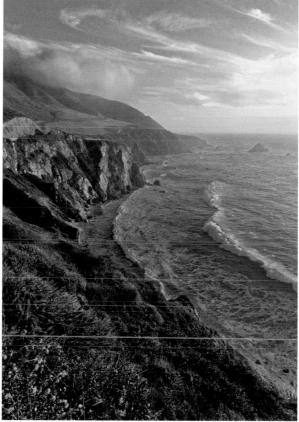

Active waves on the Pacific Ocean, photographed by Dr. Jonathan Foley in Point Reyes National Seashore, California.

Great photography is more art than science, more magic than method.

Art of Nature

In most world cultures, nature
has been the inspiration for
some great art (and even more lesser art). By looking at nature as art, we invite
a more personal expression by the photographer, and interpre-
tation by the viewer. Yet the appeal is universal—we are drawn
to the repeating patterns, contrasts of color, and incongruous
shapes. They resonate with our ancient selves.

Art in nature takes on many forms. Among a shimmering field
of long grasses, its many shades capturing depth and movement,
we discover a lion. Or our eye is captivated by expressive red
lines on a mottled background. We linger longer to decipher the
image. But the perception of beauty changes when we realize
with dismay that the marks are bloody gashes on the skin of a
wounded hippopotamus.

As we look beyond representation, we evoke the imagination.
A leaf cradles a drop of water like a precious pearl. We look even
closer, and see our world under a microscope where the ordinary
is unrecognizable, abstracted into a graphic riot of color.

Or we can take the bigger view. The Earth from a distance
surprises us with its majestic patterns—and its clues to land
health and use. But add pink flamingos in formation, along with
their shadows, and we clearly see the art of nature.

The pattern of the leaves and transition of color from red to yellow form a unique rhythm within this intriguing image. The drops of water breathe vibrant life into a scene of beauty that could be overlooked.

—SANDRA BARTOCHA, NATURE AND FINE-ART
PHOTOGRAPHER AND BIGPICTURE COMPETITION JUDGE

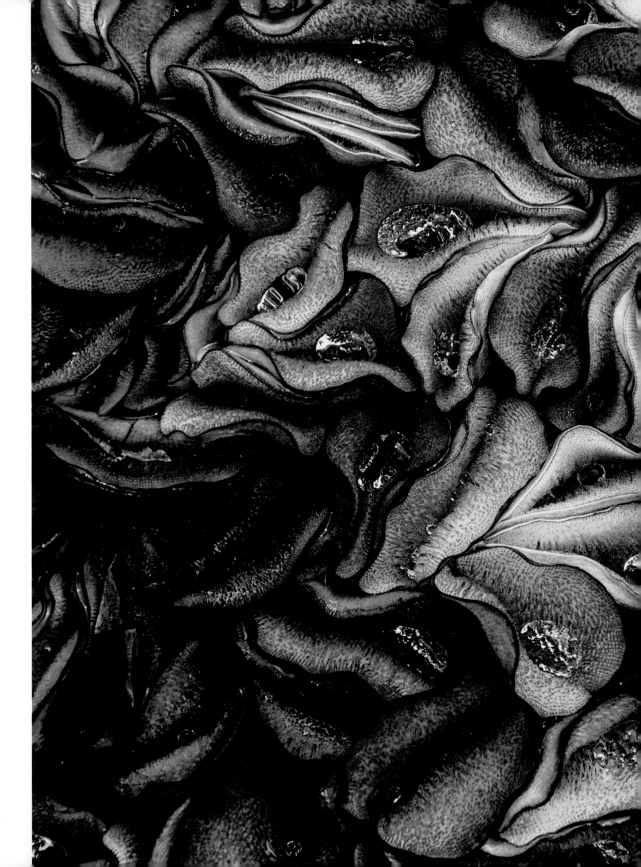

Water Pearls
Yingting Shih

Kariba weed (*Salvinia molesta*)
Taoyuan, Taiwan

Shih was enchanted by this aquatic fern floating in a pot at an old tea factory. The plant has a reputation as a highly invasive weed when it escapes into natural streams. But here, Shih saw a treasure within its leaves, where water drops gleamed like pearls in oyster shells. "Water is one of the most critical elements on Earth for the survival of all beings," he says, "so just like pearls, water is precious and should be appreciated."

Serpentine Nature
Mac Stone

Eastern corn snake (*Pantherophis guttatus*)
Live oak (*Quercus virginiana*)
Kanapaha Prairie, Gainesville, Florida, USA

Nature is the ultimate artist, as was revealed when Stone spotted this corn snake in Kanapaha Prairie. "As it crawled over a fallen live oak," he says, "its colors and form contrasted beautifully with the aged wood grain."

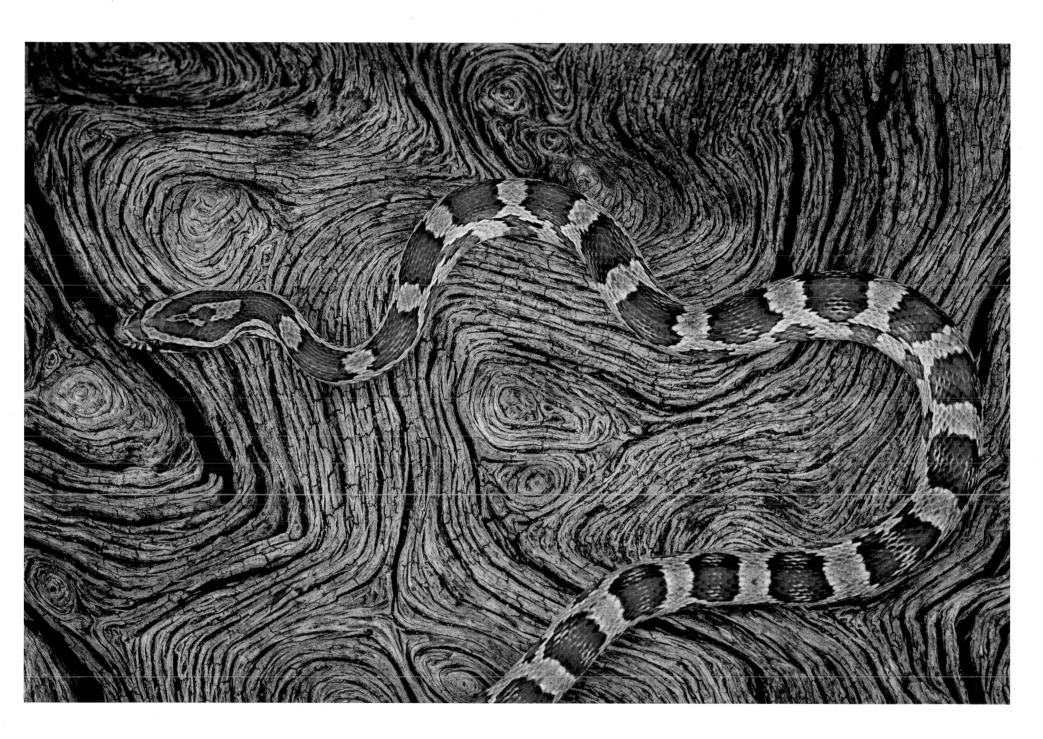

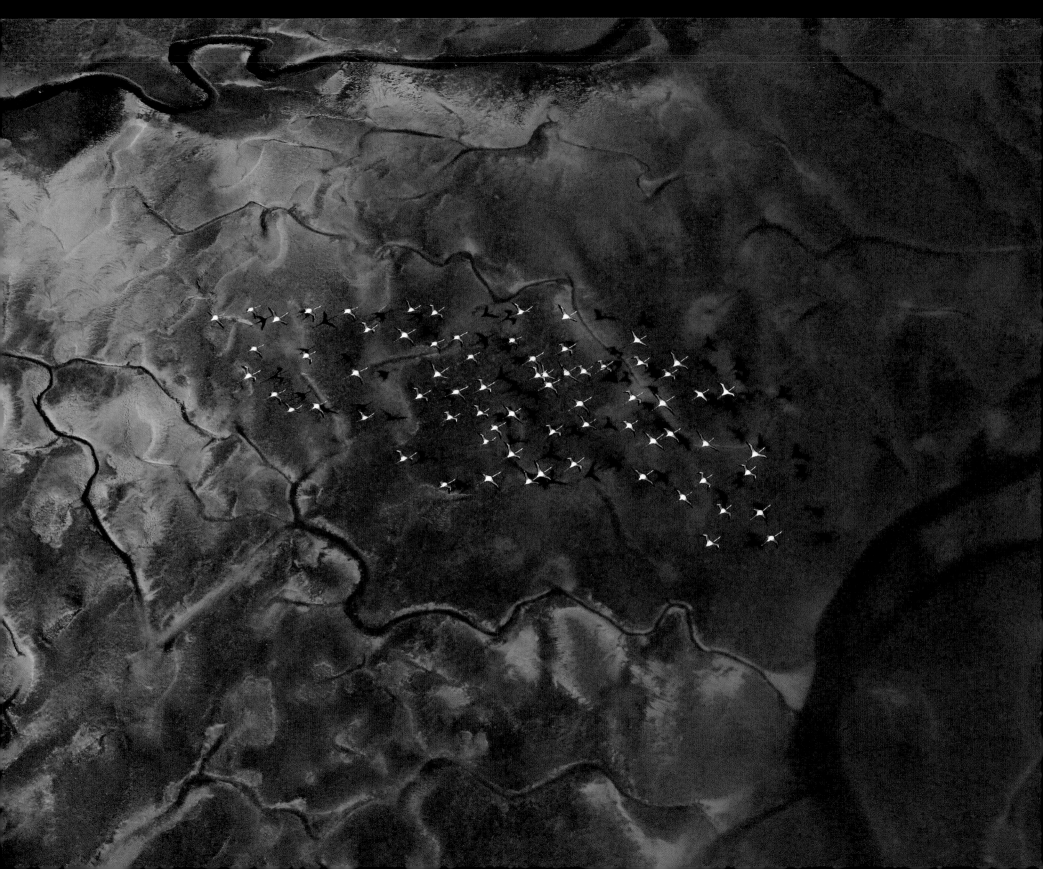

Pink Flamingos at Red River
Francisco Mingorance

American flamingo (*Phoenicopterus ruber*)
Rio Tinto, Huelva, Spain

Although birds are rare at Rio Tinto due to its highly
acidic waters, these flamingos flocked to the river delta
after torrential rains. The aerial view reveals streams
tinged emerald by bacteria.

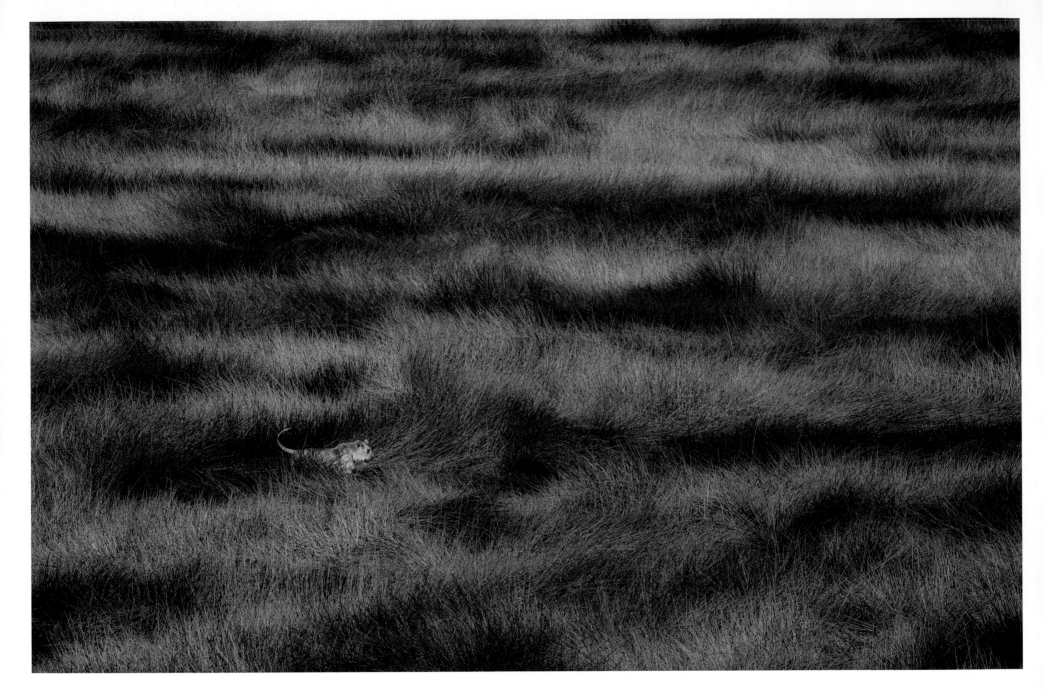

Sea of Grass
Gian Luigi Fornari Lanzetti

Lion (*Panthera leo*)
Ndutu, Ngorongoro Conservation Area, Tanzania

Fornari Lanzetti and his guide observed a lioness vanish into tall swamp grasses in the Serengeti. Thinking that a nearby hill could offer a better vantage point, they drove there just in time for the photographer to capture the lioness returning from her cubs' hideout.

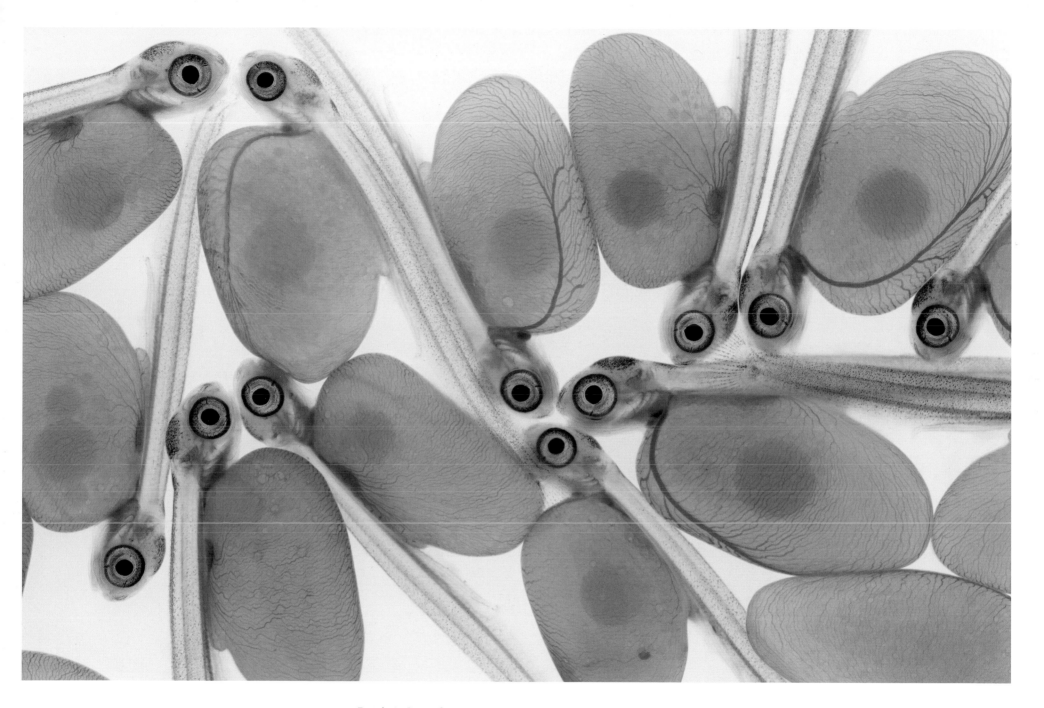

Ready to Launch
Amy Gulick

Newly hatched Chinook salmon (*Oncorhynchus tshawytscha*)
Puget Sound, Washington, USA

Wild salmon are tough and adaptable. They are also essential to ecosystems, economies, and indigenous cultures. Nourished in their first few weeks by bright orange yolk sacs that act as built-in lunch boxes, these newly hatched salmon embody their species' resilience.

113

Many bats pollinate plants, disperse seeds, or devour obnoxious insects. From my perspective of studying virus evolution, bats are also quite a puzzle: They harbor an incredible variety of viruses, without getting sick! That may be due to their fever-like body temperature—resulting from a high metabolism that helps make them the only mammal capable of sustained flight.

—SHANNON BENNETT, ASSOCIATE CURATOR OF MICROBIOLOGY AT THE CALIFORNIA ACADEMY OF SCIENCES

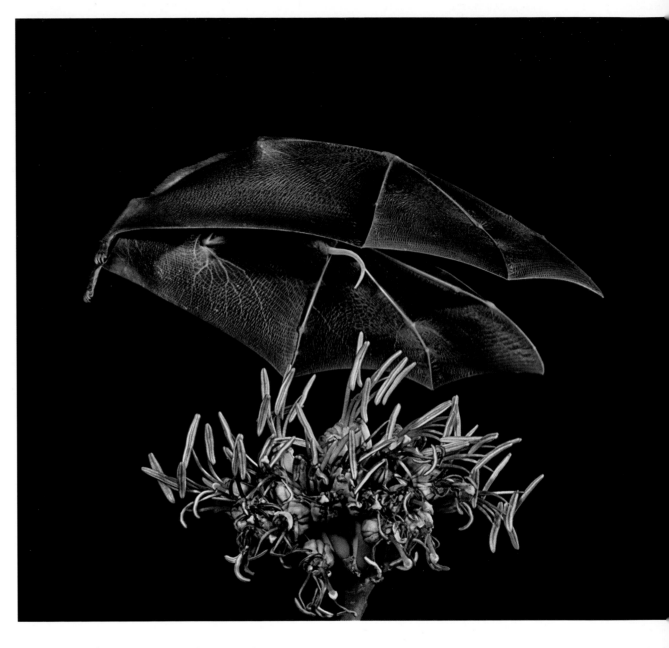

Fair Trade
Terry Turrentine

Lesser long-nosed bat (*Leptonycteris yerbabuenae*)
Palmer's century plant (*Agave palmeri*)
Green Valley, Arizona, USA

The endangered lesser long-nosed bat, frozen here in mid-flap, gathers nectar from agave and night-blooming cacti—and pollinates them. "Bats are extremely intelligent and provide extraordinary benefits to natural ecosystems and humankind," says Turrentine.

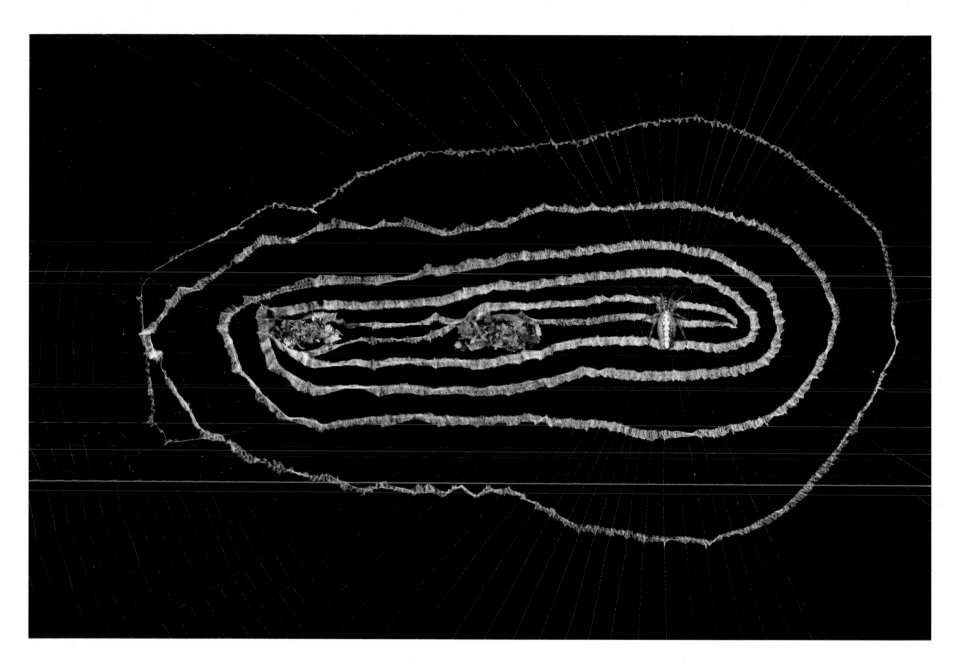

Web Designer
Des Ong

Trashline spider (*Cyclosa* sp.)
Tabin Wildlife Reserve, Malaysian Borneo

A macro view of the little trashline spider's web reveals a spiral decoration with clusters of collected debris—camouflage to hide the arachnid from predators.

Survivor
Mohammed Yousef

Hippopotamus (*Hippopotamus amphibius*)
Maasai Mara National Reserve, Kenya

Yousef encountered a wounded
hippopotamus that had wandered far
from the river in Maasai Mara, apparently
exiled from its group. "We need to get a
bit closer to feel the pain suffered by the
animals," he says.

We ordinarily see the world as a mélange of colors as light reflects off the complex materials around us. But the simple molecular structure of these crystals weeds out most of the light passing through, so we experience single wavelengths of light—pure colors— in an extraordinary way.

—RYAN WYATT, SENIOR DIRECTOR OF THE MORRISON PLANETARIUM AND OF SCIENCE VISUALIZATION AT THE CALIFORNIA ACADEMY OF SCIENCES

Sulfur City
Peter Juzak

Microscopic view of sulfur crystals in polarized light
Wennigsen, Germany

After Juzak melted sulfur on a microscope slide, the substance— often used in makeup—cooled into crystals. Viewing them at 120x magnification reveals a colorful landscape with bizarre shapes. "The view into the invisible becomes an adventure, the mundane becomes the magical," he says of his experiments. "Photographing in the microcosm is always full of surprises. At the moment I saw this picture, I got the association of a megacity in my mind."

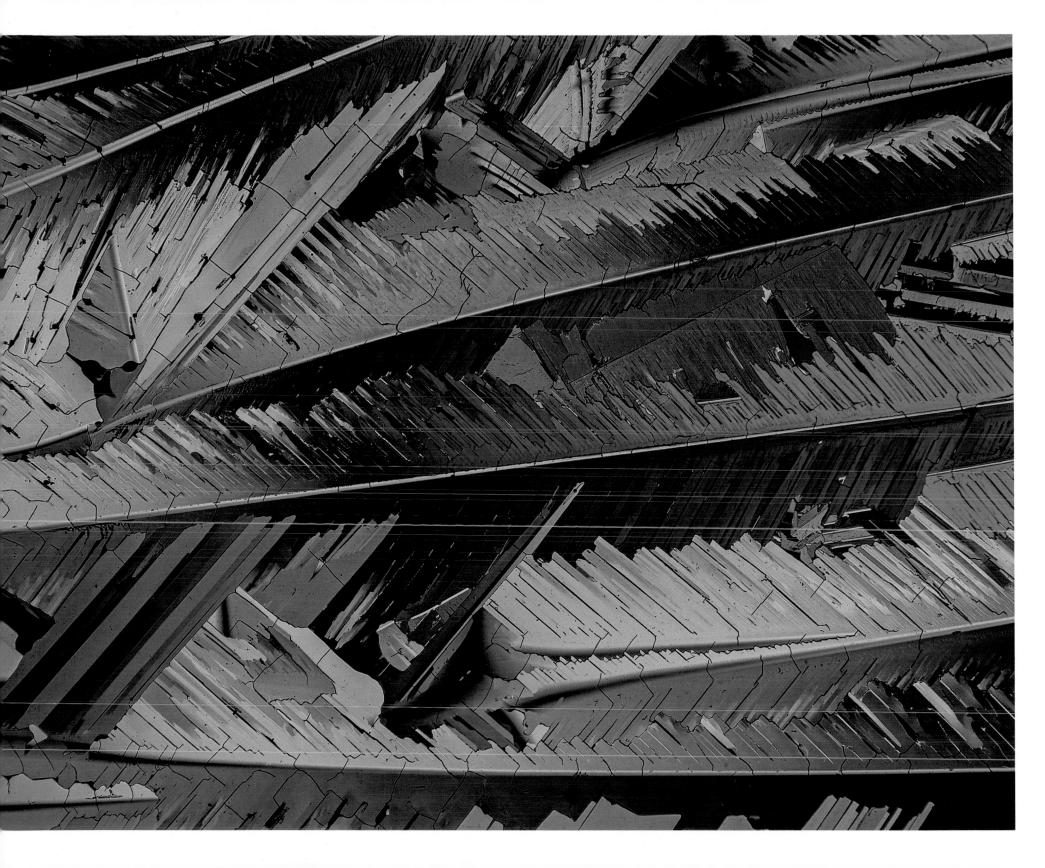

Revealing the Structure of Substance

Though they are common companions in our everyday lives, we rarely stop to consider what makes up vitamin C, acetaminophen, or sulfur. These substances—found in food, medication, and makeup—hardly seem mysterious. Yet when turned into micro-crystals (crystals whose structure is only visible under a microscope) and photographed through the microscope, they suddenly become visible and create a surprising world of wonders.

Not unlike pieces of abstract modern art, these pictures invite us to create our own associations—as multifaceted as the crystals. I can never be sure what will appear, whether or not the crystals will open up a universe of shapes and colors. As the photographer succeeds in revealing the obscure, nature reveals itself within the art. These microcrystals exist on the frontier between art and science.

I first became fascinated by microscope photography 30 years ago after reading a book on the topic. I borrowed a microscope from a pharmacist and have since photographed over 40 substances, from urea to citric acid and lots of pain medications.

To make the "Sulfur City" image, I put a small amount of sulfur on a slide and covered it with glass. The sulfur is melted on a hotplate and then cooled to room temperature until the sulfur crystallizes. The slide is then put into a polarizing microscope with camera and shot at a magnification of 120:1. A single slide can produce hundreds of images, a journey through colorful landscapes and fantastic shapes.

—PETER JUZAK

Living in the Anthropocene—
the geologic era dominated
by human influence—we may forget that humans are a part of the natural world. Nature photographers remind us by creating compelling stories through images that draw attention to conservation issues, highlight human efforts to preserve other species, and show the diversity of life forms with which we share our world.

Humans may not be visible in these photographs, but they are present. The depictions provoke us to discover a backstory. The surreal image of a two-ton ungulate floating above the mountains makes us feel for the dwindling rhinoceros population and appreciate the extraordinary efforts needed for each rescue.

Are the animals encroaching on our carefully constructed world? Or are we encroaching on theirs? From a mountain lion looming over the lights of the Hollywood sign to a giraffe dwarfing the skyscrapers of Nairobi in a national park, the juxtapositions are striking.

Camera traps—hidden in the environment, triggered to take periodic photographs—allow photographers to capture unobserved animal behavior. Securely setting up the camera is only the first challenge; it may take months to produce and review thousands of uneventful images to find the one that captures the lone leopard in the urban alley.

In this chapter, animals are the focal point, but the perspective highlights the impact of humans—from conservationists to kids—on nature. These images remind us that we are much less than the one percent. Humans coexist with the 99.99998 percent of other living things in the complex network that we call life on Earth. Let's keep it that way.

Human/
Nature

Never have I seen such a powerful photo depicting the intense care and dedication it takes to help save these iconic pandas from extinction in the wild. The body language takes the image to another level.

—PETE OXFORD, CONSERVATION PHOTOGRAPHER, CO-OWNER AND OPERATOR OF FOCUS EXPEDITIONS, AND BIGPICTURE COMPETITION JUDGE

Pandas Gone Wild
Ami Vitale

Giant panda (*Ailuropoda melanoleuca*)
Human (*Homo sapiens*)
Wolong National Nature Reserve, Sichuan Province, China

A panda cub gets a rare hands-on checkup at the Hetaoping center in Wolong reserve, where a government program is training captive-bred bears to survive in the wild. Workers don costumes scented with panda urine to keep the finicky animals from getting used to humans. Thanks in part to China's forest-habitat protections, this beloved bear was taken off the endangered species list in 2016. But with only a few thousand in the world, the species remains vulnerable.

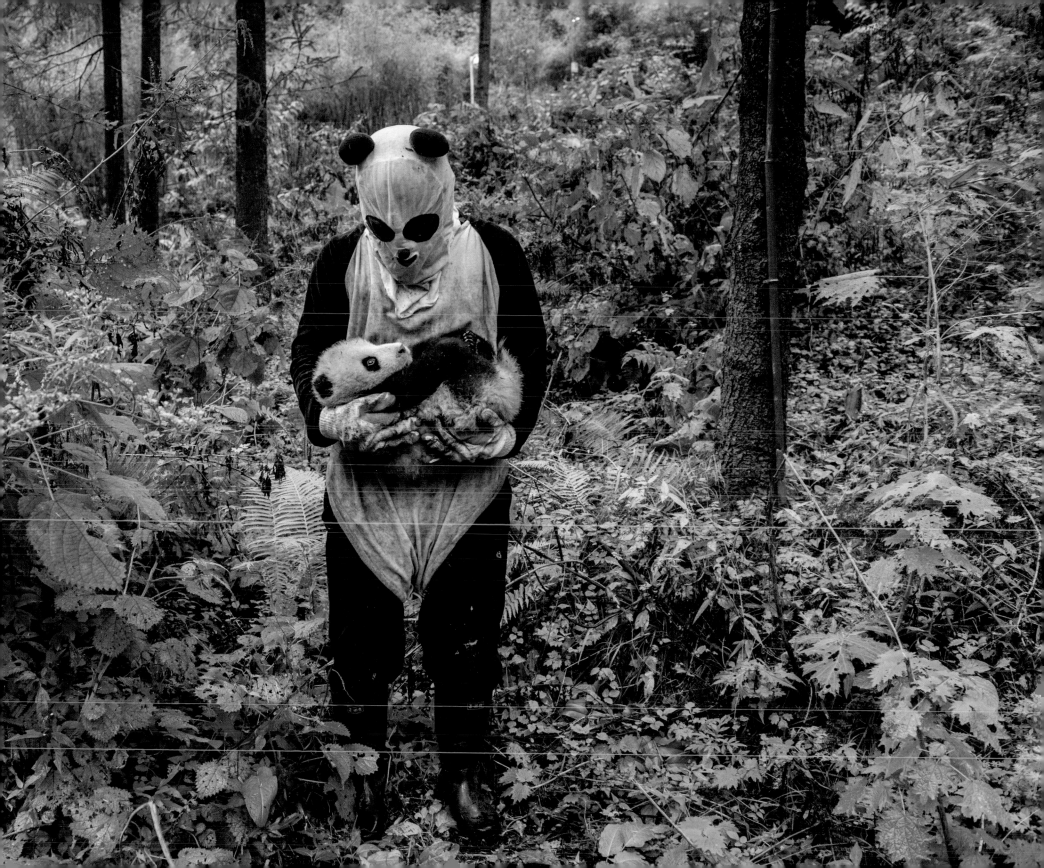

Landfill of Plenty
Jasper Doest

White stork (*Ciconia ciconia*)
Andalusia, Spain

A symbol of new life and prosperity, the once nearly extinct white stork is thriving in Europe. Instead of migrating to Africa in the winter, these birds now live year-round on food waste at landfills.

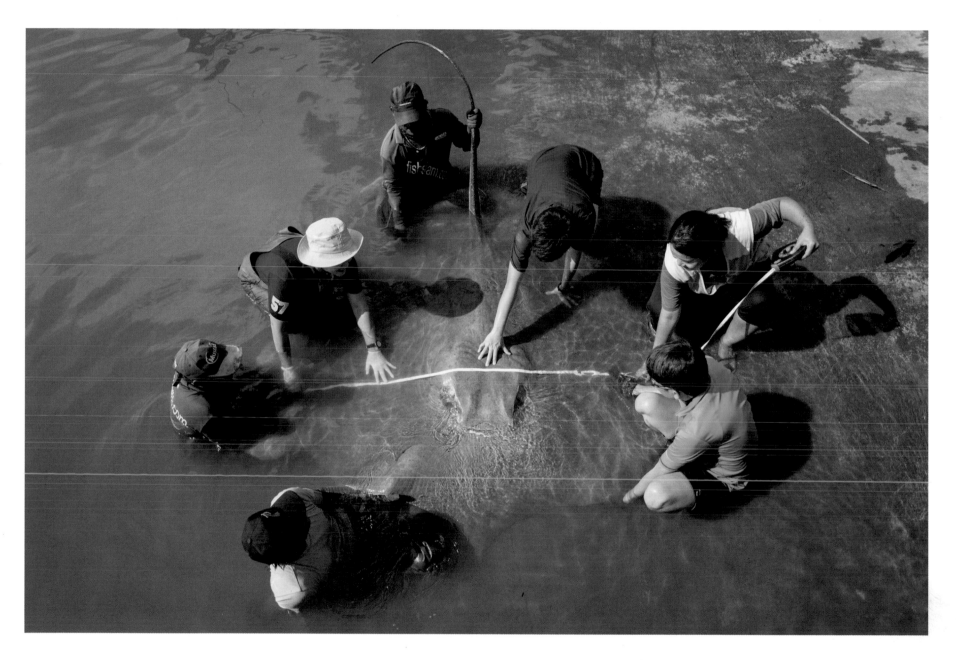

Ray of Hope
Sirachai Arunrugstichai

Giant freshwater whipray (*Urogymnus polylepis*)
Human (*Homo sapiens*)
Mae Klong River, Samut Songkhram Province, Thailand

The giant whipray is critically endangered due to fishing and degradation of river habitats. Working with fishermen in Amphawa District, conservation researchers catch specimens for study. Here, they take measurements before releasing the ray.

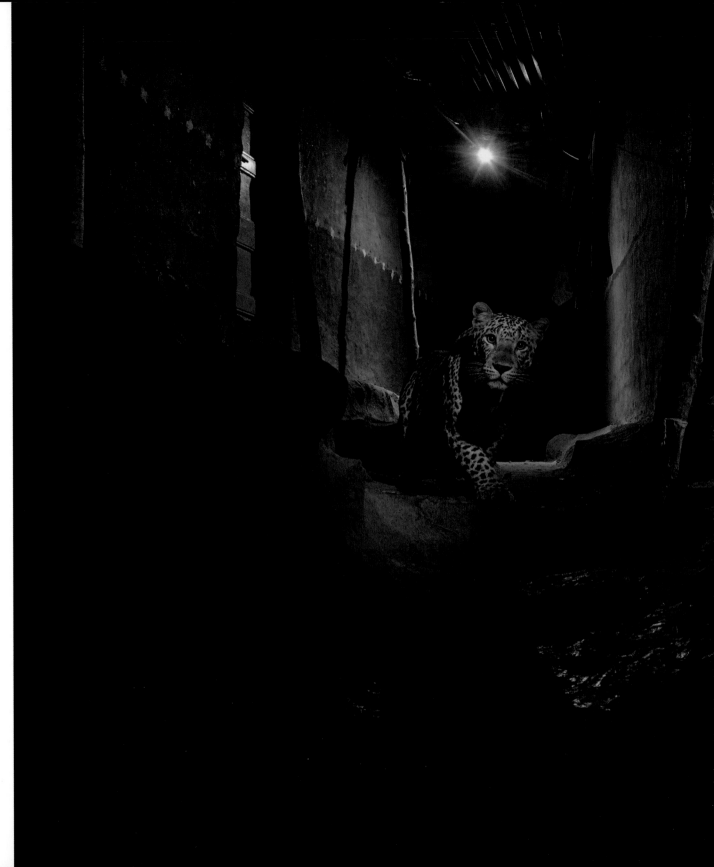

The Cat in My Backyard
Nayan Khanolkar

Leopard (*Panthera pardus*)
Aarey Milk Colony, Mumbai, India

Leopards prowl at night through this area of cow sheds and housing near Sanjay Gandhi National Park. Some residents are members of the indigenous Warli tribe, who have learned to appreciate and live with the big cats despite the occasional too-close-for-comfort encounter. One tribal member let Khanolkar place a camera trap in his backyard. Four months of patience yielded this startling evidence of a unique coexistence between humans and leopards.

Viewing Nayan Khanolkar's image, we are drawn to the animal's eyes, then the paw that holds deliberate tension. This backyard photograph works so wonderfully because it reminds us that we are not apart from nature.

—NEIL EVER OSBORNE, CONSERVATION PHOTOGRAPHER AND BIGPICTURE COMPETITION JUDGE

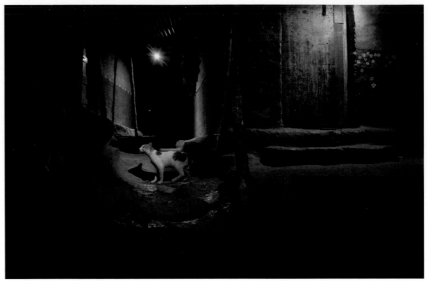

Caught Between Two Worlds

What's urban today wasn't so yesterday. I live in Mumbai, one of the few cities in the world with a National Park in the center of the city. Sanjay Gandhi National Park is surrounded by a small tribal settlement, which acts as an unofficial buffer zone for the high-rise dwellings. This park has among the highest density of leopards for a city park.

Headlines were made when leopard attacks on humans were followed by human retaliation. There was a need to monitor leopard movement in the city on a long-term basis, and, despite being rejected for funding, I decided to undertake the project.

While the Warli tribes of Mumbai were used to leopards moving through the alleys of their settlements, I had to convince

them that documenting this would help alleviate the human-animal conflict. Their cooperation meant that they provided timely information and protected the cameras. Many Warli tribe members—like those to whom this house belongs—coexist with the big cats, in spite of their occasional close encounters. The remarkable story captured over four months was that of coexistence: Photographs depict the leopard movements as well as the daily activities of the inhabitants on the path.

The moment I saw that alley and learned that there was leopard movement along it, the picture was created in my mind. The idea was to get a photo of a leopard integrated into the urban environment without letting the subject dominate the

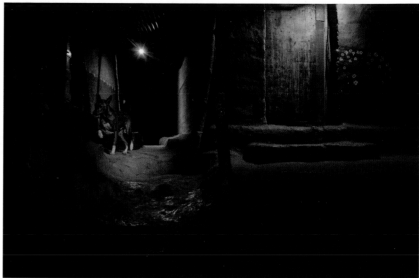

image—thereby bringing out its adaptive nature. The house and the steps formed an important part of the composition, along with the reflecting light. I deliberately matched the strobes to re-create lighting typical of the Mumbai settlements. I kept the camera for four months in that location without any success. Before placing my DSLR (digital single-lens reflex) camera trap, I verified the leopard movement with an infrared (IR) camera. (The infrared sensor, triggered by movement, activates the shutter.) Once the DSLR was in place, I kept an IR camera outside the alley to monitor leopard movement. But after the IR camera was stolen, I decided to remove my DSLR camera trap, fearing its theft as well. When my local volunteers arrived the next morning to remove the setup, they found the leopard picture taken at 3 a.m. that same day!

The picture captured here is a secretive walk of a shy cat looking straight into the eyes of its sole witness: my camera. The Mumbai urban leopard in its true glory.

—NAYAN KHANOLKAR

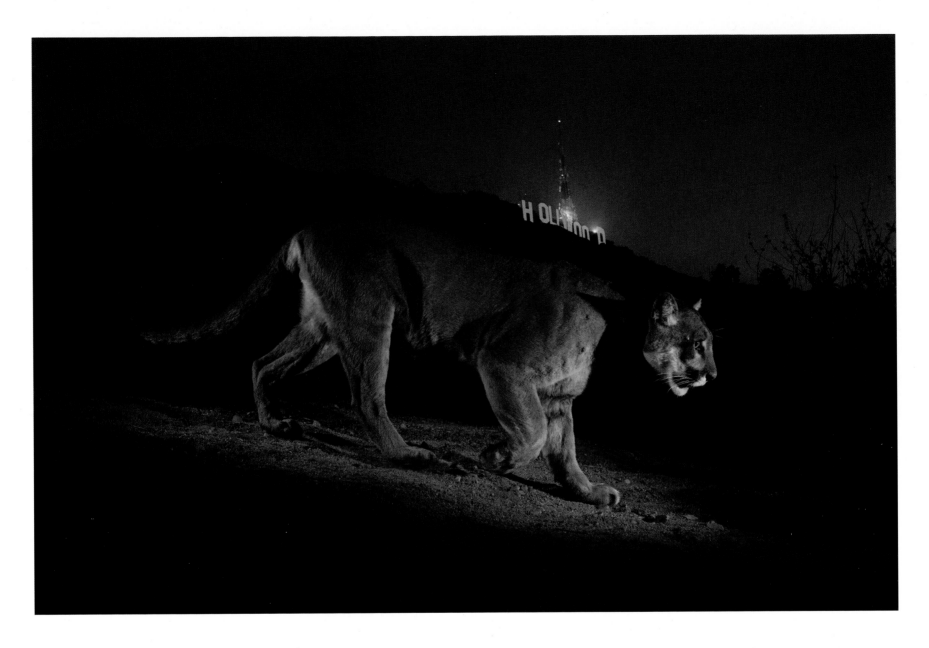

Cougar in Tinseltown
Steve Winter

Cougar (*Puma concolor*)
Griffith Park, Los Angeles, California, USA

For a photo series on cougars in urban areas, Winter wanted to capture one near the Hollywood sign. After months of waiting, a male cat tagged with a GPS collar by a wildlife-tracking project was spotted in the Hollywood hills. Winter then found the ideal camera trap location to get this portrait—seen from a cougar's eye level.

Swept Up
Francisco Mingorance

Fennec fox (*Vulpes zerda*)
Human (*Homo sapiens*)
Sahara Desert, Morocco

Little, big-eared fennec foxes are often trapped for meat and fur or captured and sold as pets. This desert-dwelling species used to range across northern Africa, but its natural habitat is under pressure from humans. Will this rare fox be saved?

When Rhinos Fly
Pete Oxford

Black rhinoceros (*Diceros bicornis*)
Great Fish River Nature Reserve, Eastern Cape Province, South Africa

A Huey helicopter lifts a black rhino—blindfolded to reduce stress—skyward, relocating it to establish a small breeding population elsewhere. Airlifting is quicker and requires less anesthetic than corralling these critically endangered animals and transporting them by truck.

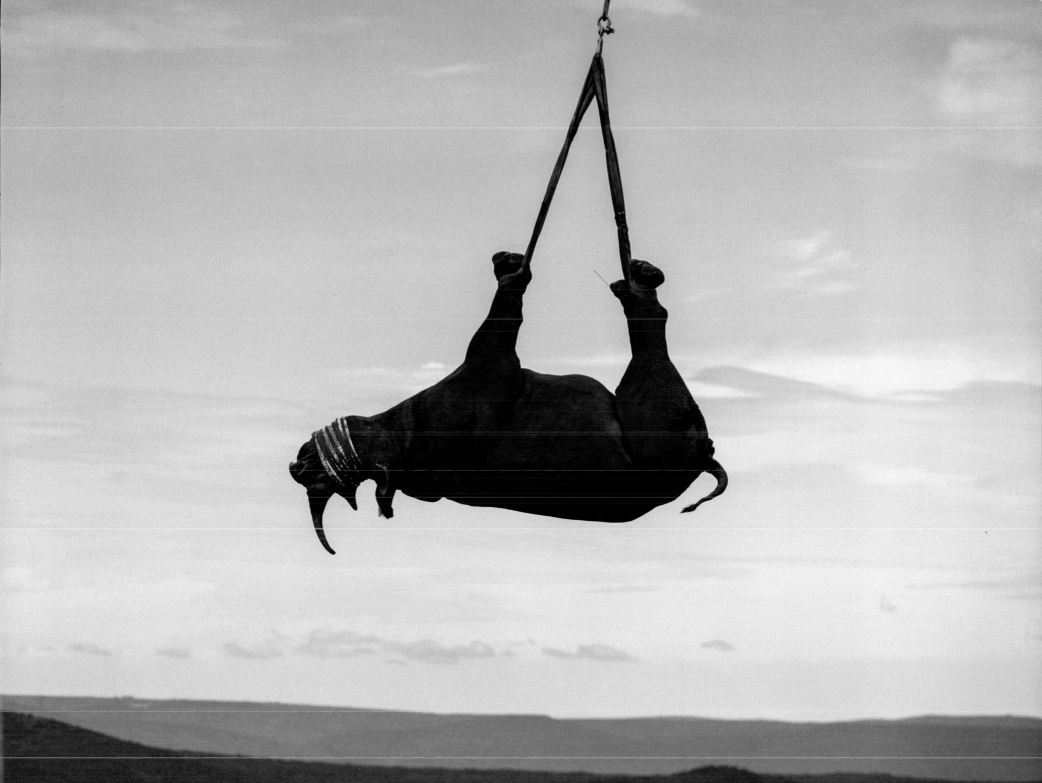

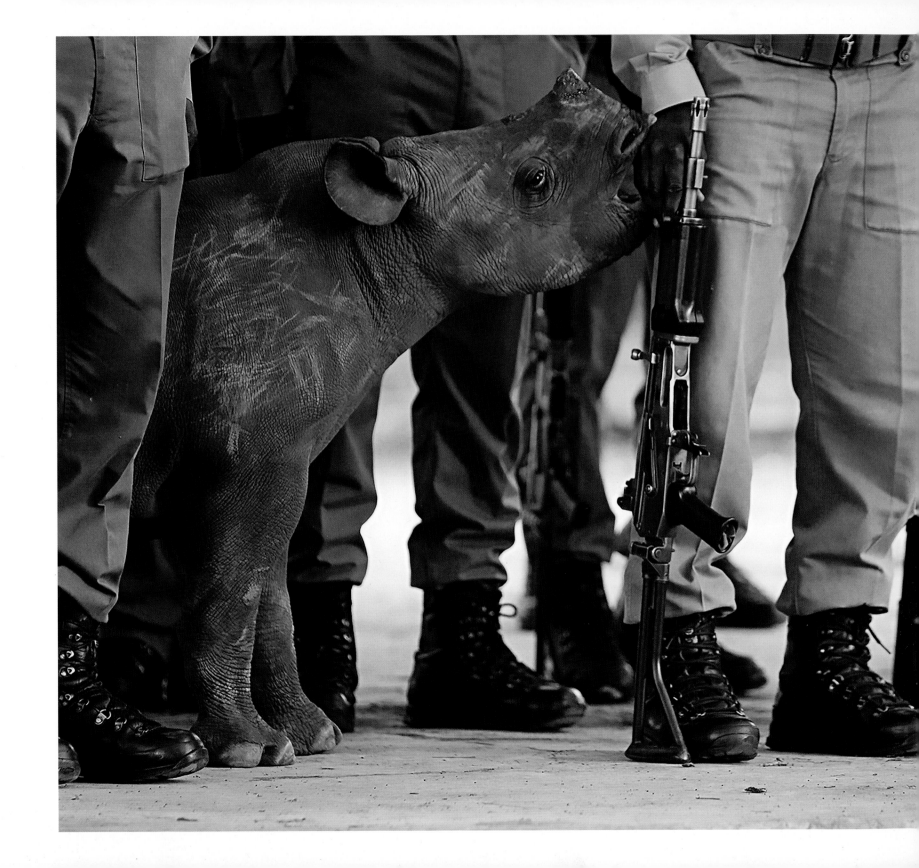

A powerful image. The motherless baby rhino mouthing the human hand tugs at your heartstrings. The presence of the anti-poaching team with guns is a strong message about what it takes to protect this species from extinction.

—SUZI ESZTERHAS, WILDLIFE PHOTOGRAPHER AND BIGPICTURE COMPETITION JURY CHAIR

Defenders of Innocence
Hilary O'Leary

Black rhinoceros (*Diceros bicornis*)
Malilangwe Wildlife Reserve, Zimbabwe

When a black rhino calf was found lost and dehydrated, it was brought in for rehabilitation at Malilangwe Reserve. There, anti-poaching scouts are caring for it until it grows older. Illegal hunting of black rhinos for their horns has almost extinguished this African species. O'Leary says, "We can save them, but time is running out, and the burden of responsibility is currently carried by few."

The Photographers

Octavio Aburto
San Diego, California, USA

A professor at the Scripps Institution of Oceanography, Aburto photographs marine reserves and species that are exploited by fisheries in Mexico, Belize, and the U.S.

Page 26

Eduardo Acevedo
Los Realejos, Canary Islands, Spain

A Canary Islands native, Acevedo has specialized in underwater photography since 1998. He dives the world's oceans from Africa to Malaysia, camera in hand.

Page 33

Josh Anon
San Francisco, California, USA

Anon travels the globe in search of the next great picture. He has coauthored books on photography with his mother and also makes movies.

Page 91

Sirachai Arunrugstichai
Bangkok, Thailand

Arunrugstichai first started taking pictures as a biologist studying coral reefs in Thailand. Today he is a photojournalist whose images tell marine conservation stories.

Page 127

Javier Aznar González de Rueda
Quito, Ecuador

Aznar is a Spanish biologist with a special passion for reptiles, amphibians, and arthropods. His photography focuses on their oft-unappreciated beauty.

Page 67

Emanuele Biggi
Genoa, Italy

An environmental scientist, Biggi works to raise awareness about lesser-known species and their roles in ecosystem health.

Page 64

Filippo Borghi
Siena, Italy

Drawn to remote areas of the globe, Borghi is on a quest to uncover the exceptional and unusual. He specializes in underwater photography.

Pages 18 & 29

Marcio Cabral
Brasilia, Brazil

Cabral specializes in photographing landscapes and spherical panoramas. He publishes his work in travel magazines, books, and guides about Brazil.

Pages 78 & 93

Kristhian Castro
Cali, Colombia

A self-taught photographer, Castro specializes in wildlife and macro photography. He seeks to raise awareness of conservation issues by conveying to viewers the inspiration he experiences in nature.

Page 63

Paras Chandaria
Nairobi, Kenya

Wildlife photography has moved Chandaria, a businessman, toward conservation. "We cannot sacrifice our heritage, nature, and wildlife for development," he says.

Page 2

Ray Collins
Thirroul, Australia

In 2007, Collins purchased his first camera to take photos of waves near his hometown. Now his work can be seen in international museums, galleries, and advertising campaigns.

Page 85

Jules Cox
Brighton, England

Photographing the wildlife and wilderness of the British Isles and the Arctic North is a passion for Cox. He frequently shoots for *BBC Wildlife Magazine*.

Page 68

Jaime Culebras
Cáceres, Spain

As a child, Culebras borrowed his father's camera to snap pictures of anything he found crawling under rocks and trees. Now he photographs wildlife in the Amazon.

Page 62

Giuseppe DeMasi
Laguna Beach, California, USA

DeMasi began his career as a photojournalist at the age of 17. He is a bikini and surfing photographer by trade, but he sees beauty everywhere around us.

Page 88

Jasper Doest
Vlaardingen, Netherlands

Self-taught photographer Doest wants to give a voice to the wild creatures who share our planet. His work depicts what is beautiful in the world, and with his photographs he is able to reveal how fragile this beauty is.

Pages 59 & 126

Gian Luigi Fornari Lanzetti
Rome, Italy

Africa's magnificent wildlife and landscapes inspired Fornari Lanzetti to leave behind his career in finance and pursue nature photography full-time instead.

Page 112

James Gifford
Maun, Botswana

Wildlife photographer Gifford says that his quest "to capture an animal's essence in a single split-second, in an innovative way, is simultaneously rewarding and highly addictive."

Page 66

Daisy Gilardini
Vancouver, Canada

Acclaimed Swiss-born photographer Gilardini has gone on more than 50 expeditions to Antarctica and the Arctic, where rugged isolation reconnects her with nature and the Universe.

Page 69

Amy Gulick
Clinton, Washington, USA

Award-winning conservation photographer Gulick says her work prompts her to stop, look, and see that she is "a small part of an extraordinary world."

Page 113

Pål Hermansen
Oslo, Norway

A childhood spent outdoors fostered Hermansen's love of nature, conservation, and exploration. He has written and illustrated 25 books about the natural environment and exhibited his photography worldwide.

Page 53

Denise Ippolito
Brielle, New Jersey, USA

Enthralled with wildlife since childhood, Ippolito seeks to convey that animals depend on our stewardship of the natural world. She was a winner in the 2015 and 2016 Nature's Best Photography competition.

Page 39

Peter Juzak
Wennigsen, Germany

Juzak experiments with photographing crystals of everyday chemical ingredients—in food, medicines, and cosmetics—through a microscope lens. He has contributed to medicalpicture.com, a database of medical images and illustrations.

Page 119

Shane Kalyn
Vancouver, Canada

A fisheries scientist who counts salmon from a helicopter, Kalyn explores parts of British Columbia that most people never see—and brings along his camera.

Page 101

Sebastian Kennerknecht
Berkeley, California, USA

Kennerknecht is wild about wild cats. He works around the world with conservation organizations such as Panthera to photograph these elusive felines and has started Cat in Thin Air, a photojournalist endeavor to conserve the Andean cat.

Page 71

Nayan Khanolkar
Mumbai, India

Naturalist and photographer Khanolkar studies the interactions and conflicts between leopards and people around Sanjay Gandhi National Park in Mumbai. His images offer insights into the wild cats' behavior and the conservation threats they face.

Page 128

Steven Kovacs
Loxahatchee, Florida, USA

Canadian-born Kovacs grew up exploring the chilly waters of Vancouver, but moved to Florida to pursue his obsession with underwater photography in a warmer setting.

Page 19

Zsolt Kudich
Budapest, Hungary

Kudich's passion is creating images that capture nature's fragile balance in an artistically powerful way. His latest project took him to eight countries to explore a string of reserves along the Danube River— the last untouched floodplains in the river basin.

Page 47

Maroesjka Lavigne
Ghent, Belgium

Lavigne gained her Master's in Photography at Ghent University in the summer of 2012. She says she loves photographing places "where you can imagine how the world must have been before there were people."

Page 75

Dick Lavine
Austin, Texas, USA

Lavine appreciates the photographer's enhanced vision of the world, whether the subject is nature or Austin's street scenes.

Page 92

C. S. Ling
Singapore, Singapore

A professional photographer for 10 years, Ling won the grand prize in the 2012 Nature's Best Photography competition. She teaches photo workshops for all ages.

Page 48

Manish Mamtani
Peabody, Massachusetts, USA

Born in Nagpur, India, Mamtani works as a consultant in information technology and finance. He devotes weekends to nature photography, focusing on the majesty of America's national parks.

Page 99

Milko Marchetti
Ferrara, Italy

Professional photographer Marchetti sees photographers as naturalists. "I love pistils of flowers, carpets of mosses," he says. "I love a piece of ice that glows in the sun."

Page 90

Scott Marmer
Mountain View, California, USA

From dusty savannas to lush rain forests, stunning landscapes have captured Marmer's imagination and become the focus of his photography.

Page 76

Graham McGeorge
Jacksonville, Florida, USA

As a child, McGeorge was introduced to wildlife photography by his grandfather. Now a union foreman, he plans vacations around his passion.

Page 38

Francisco Mingorance
Almuñécar, Spain

Mingorance has been a professional wildlife photographer for three decades. And for more than 25 years he has been a graphic reporter for the best newspapers, magazines, and editorials all around the world.

Pages 36, 110, & 133

Adriano Morettin
Trieste, Italy

Photographer and diving instructor Morettin was born in Trieste, a city of seafaring traditions. He has always been drawn to the world beneath the ocean surface.

Page 30

Francisco Negroni
Frutillar, Chile

Negroni is a freelance photo-journalist who works for international media agencies including Reuters and The Associated Press. He has an affinity for shooting volcanic landscapes in southern Chile.

Page 96

Hilary O'Leary
Harare, Zimbabwe

O'Leary, a native of Zimbabwe, rides bikes, adores horses, and revels in the great outdoors. For her, the African bush is the best place to arrive and the hardest to leave. "My camera goes everywhere with me," she says.

Page 136

Des Ong
Loughborough, England

Born in the tropics, Ong grew up fascinated by the incredible diversity of local plants and animals. Wildlife photography combines his two passions, art and nature.

Page 115

Pete Oxford
Quito, Ecuador

Oxford, a veteran British photographer, has published images in the world's major magazines. The best reward, he says, is when his pictures change people's attitudes about the environment.

Page 135

Ralph Pace
San Diego, California, USA

Natural history photographer Pace has a marine conservation degree. His images have been used by the Nature Conservancy and other organizations working to safeguard our oceans.

Page 32

Michael Pachis
Memphis, Tennessee, USA

Pachis's passion for photographing wildlife is his creative outlet from a 40-year career as a computer technologist. Through his images, he hopes to evoke empathy for animals as fellow inhabitants of our world.

Page 52

Baiju Patil
Aurangabad, India

Undeterred by dense brush or drenching rain, Patil's hobby and passion is wildlife photography. He treks through mud and perches in the tree canopy to document the life of India's national parks.

Page 81

Alejandro Prieto
Guadalajara, Mexico

Prieto is a professional wildlife and underwater photographer from Guadalajara, Mexico. His work is mainly focused on conservation photography.

Page 21

Steve Race
Scarborough, England

A long-time naturalist and avid photographer of his native Yorkshire Coast, Race also leads nature tours and photography workshops.

Page 50

Mark Seabury
Sydney, Australia

Seabury got interested in photography in his twenties during his international travels as a surfer. In recent years, he has spent many days at sea, aiming his lens at whales from above and below the water.

Page 87

Manoj Shah
Nairobi, Kenya

Born and raised in Kenya, Shah spent many hours of his childhood observing and photographing wild animals in Nairobi National Park. His images have appeared in exhibitions in Europe and the United States.

Page 60

Yingting Shih
Taoyuan, Taiwan

Shih teaches photography as an assistant professor of visual communication design at China University of Technology in Taiwan. He hopes his images encourage viewers to pause and savor the artistry of nature that's around us everywhere.

Page 107

Paul Souders
Seattle, Washington, USA

Souders has journeyed to every continent—creating images that appear in major U.S., French, and German publications. His recent work in the Arctic has drawn wide acclaim, including National Geographic Photograph of the Year.

Pages 17 & 22

Connor Stefanison
Burnaby, Canada

Fishing, hunting, mountain biking, and camping sparked Stefanison's interest in photographing the natural world. This fascination then led him to pursue a degree focused on ecology and conservation.

Page 86

Mac Stone
Greenville, South Carolina, USA

Stone is a conservation photographer from Gainesville, Florida. Currently, his work focuses on America's swamps in an attempt to change public opinion about our country's wetlands.

Pages 41 & 109

Terry Turrentine
San Francisco, California, USA

As a girl, Turrentine learned to hunt doves and ducks. Years later, she decided to shoot birds with a camera instead, becoming a fine-art wildlife photographer.

Page 114

Marco Urso
Milan, Italy

For award-winning wildlife and travel photographer Urso, watching nature gives him "time to think, to reconsider things," and find some internal peace. His pictures have been exhibited in London, Moscow, Singapore, and Washington, D.C.

Page 49

Alex Varani
Imola, Italy

Varani took his first underwater photograph in 2009. His favorite places to dive are Indonesia and the Philippines.

Page 28

Ami Vitale
Missoula, Montana, USA

Photographer and filmmaker Ami Vitale has traveled to over 90 countries, most recently as a Nikon Ambassador and *National Geographic* photographer. She has lived in mud huts and war zones, contracted malaria, and donned a panda suit.

Page 125

Beth Watson
Salem, Missouri, USA

A photographer and Missouri landlubber, Watson found her true passion when she began scuba diving and took a camera under water. Her calling is to convey the importance of preserving our splendid and fragile ocean ecosystems.

Page 31

Steve Winter
Hoboken, New Jersey, USA

During a childhood growing up in rural Indiana, Winter dreamed of traveling the world as a photographer for *National Geographic* Magazine. He became a *National Geographic* photojournalist in 1991 and specializes in big cats.

Page 132

Mohammed Yousef
Kuwait City, Kuwait

Yousef has made many safari excursions to document nature and wildlife in Kenya. He also participates in photography projects for humanitarian campaigns in Africa and Asia.

Page 116

Kevin Zaouali
Lyon, France

Buenos Aires native Zaouali has been a wildlife photography enthusiast since age 15. He is studying biology to deepen his knowledge of animals and ecosystems.

Page 42

Acknowledgments

You have already discovered the photographers behind these spectacular photographs. I owe huge thanks to each of them for letting us share their images in this bound collection as well as to the writers who contributed essays and commentary throughout the book.

Behind these beautiful pages are many people whose ideas and endurance were critical to the making of this book. It has been a joy to work with the talented BigPicture team: Jinny Kim, designer and idealist; Kathryn Whitney, photo editor and photographer wrangler; and Amie Wong, editor and advisor. I am indebted to judge and jury chair Suzi Eszterhas, whose wisdom and expertise from Day One helped advance BigPicture's stature in the world.

We are honored that Sylvia Earle wrote the introduction, and we appreciate Liz Taylor for helping make that happen. Special thanks to Ingfei Chen, Ryder Diaz, Linda Kulik, and Tamara Schwarz for their editorial support, without which there would be unidentified species in undescribed locations. I am also grateful to the California Academy of Sciences' scientific advisors, especially Shannon Bennett, Jack Dumbacher, Lauren Esposito, Terry Gosliner, and Ryan Wyatt, for revealing the larger context of our changing world within these photographs.

This book would not be a book without its publisher, Chronicle Books. I want to thank Michael Carabetta for indulging in many conversations about possibilities, Bridget Watson Payne for green-lighting this one, and Mirabelle Korn for seeing it through.

We are deeply grateful to BigPicture's esteemed judges who generously lent their time and insights in the selection of these outstanding images: photo editors Kathy Moran and Sophie Stafford, along with renowned photographers James Balog, Sandra Bartocha, Daniel Beltrá, Clay Bolt, Melissa Groo, Paul Hilton, David Liittschwager, Klaus Nigge, Neil Ever Osborne, Pete Oxford, Thomas Peschak, Tui de Roy, Ian Shive, Brian Skerry, and Art Wolfe as well as photo curator Larry Minden.

BigPicture was fostered by the Academy, where the power of photography is harnessed to further its mission to explore, explain, and sustain life on Earth. Much support at the Academy came from Gary Sharlow, Greg Farrington, Meg Lowman, Barb Andrews, Kelly Mendez, Sterling Larrimore, Scott Moran, Melissa Felder, and Jon Foley.

Above all, I want to thank David Peters, my creative partner and husband, who consulted all along the way and proposed the title Wonders that graces the book cover, and my son, Dash, whose enthusiasm for the wonders of the world is a constant inspiration.

—Rhonda Rubinstein

Library of Congress Cataloging-in-Publication Data available.

ISBN: 978-1-4521-6456-4

Manufactured in China.

Designed by Allison Weiner, Jinny Kim, and Rhonda Rubinstein

10 9 8 7 6 5 4 3 2 1

Chronicle books and gifts are available at special quantity discounts to corporations, professional associations, literacy programs, and other organizations. For details and discount information, please contact our premiums department at corporatesales@chroniclebooks.com or at 1-800-759-0190.

Chronicle Books LLC
680 Second Street
San Francisco, California 94107
www.chroniclebooks.com

Page 2

Nairobi's Skyscrapers
Paras Chandaria

Maasai giraffe (*Giraffa camelopardalis*)
Nairobi National Park, Nairobi, Kenya

After reading of plans to build a railway through Nairobi National Park, Chandaria reached for his camera. He photographed the park's animals against the city skyline to show people that wildlife and humans can coexist.